ART OF COLORING

Disney

VILLAINS

100 IMAGES TO INSPIRE CREATIVITY

Published by Disney Editions, an imprint of Buena Vista Books, Inc. No part of this book may be reproduced or transmitted in any form or by any means, electronic or mechanical, including photocopying, recording, or by any information storage and retrieval system, without written permission from the publisher.

For information address Disney Editions, 1200 Grand Central Avenue, Glendale, California 91201

Printed in the United States of America

First Hardcover Edition, August 2016
First Paperback Edition, July 2022

3 5 7 9 10 8 6 4 2

ISBN 978-1-368-07693-7

FAC-034274-22243

ART OF COLORING

Disney

VILLAINS

100 IMAGES TO INSPIRE CREATIVITY

Disney
EDITIONS

LOS ANGELES • NEW YORK

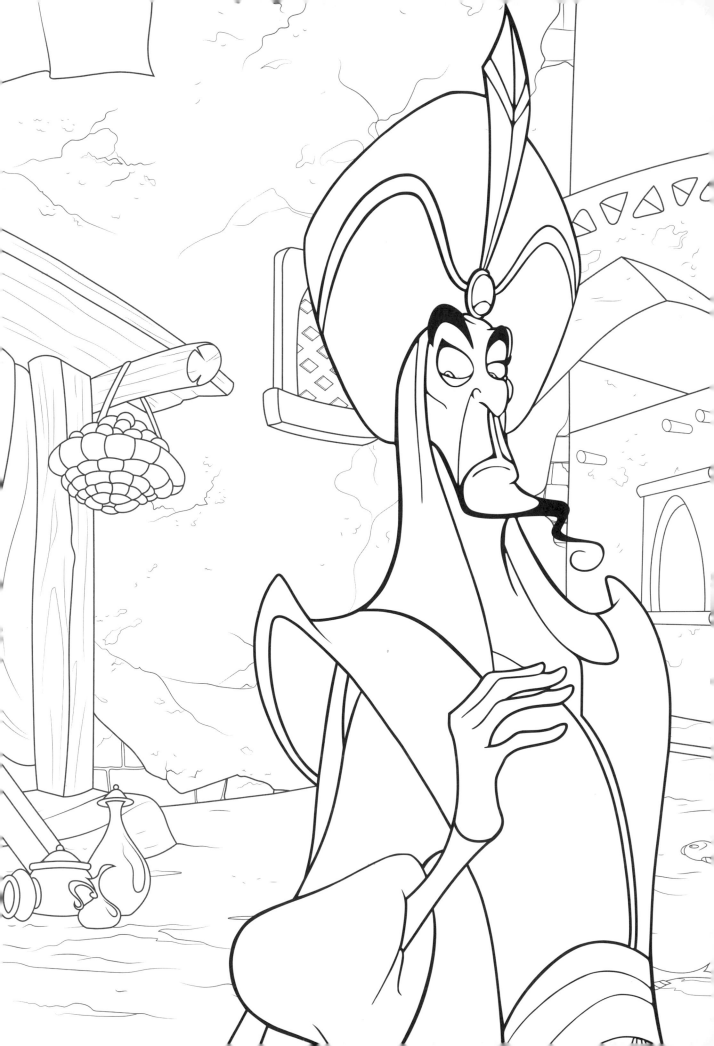

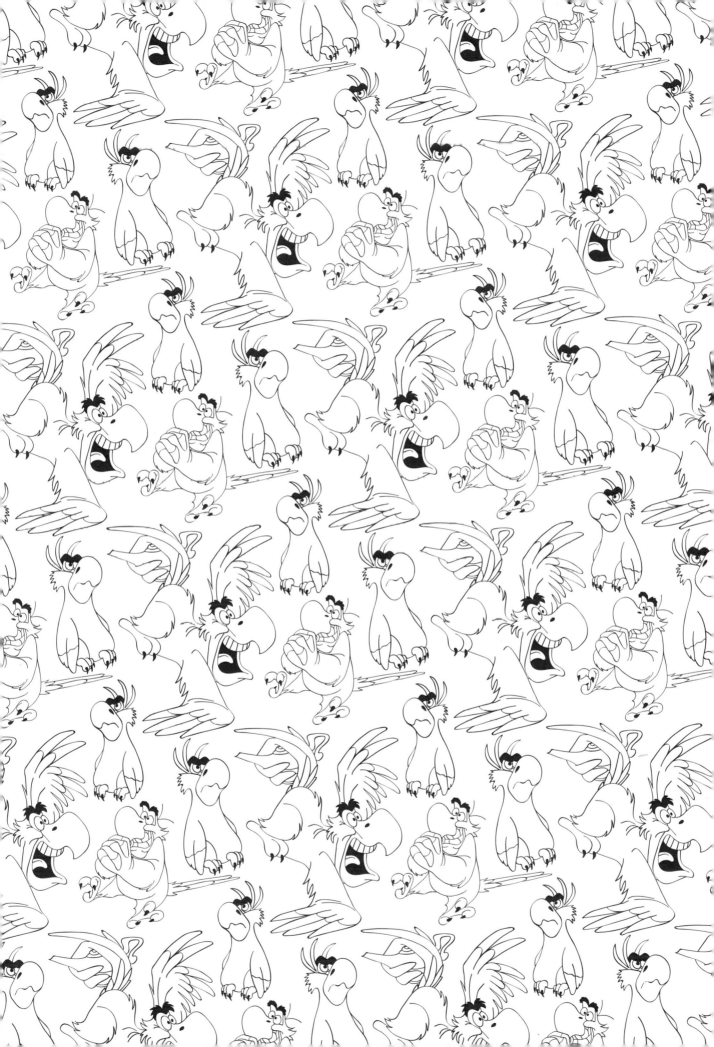

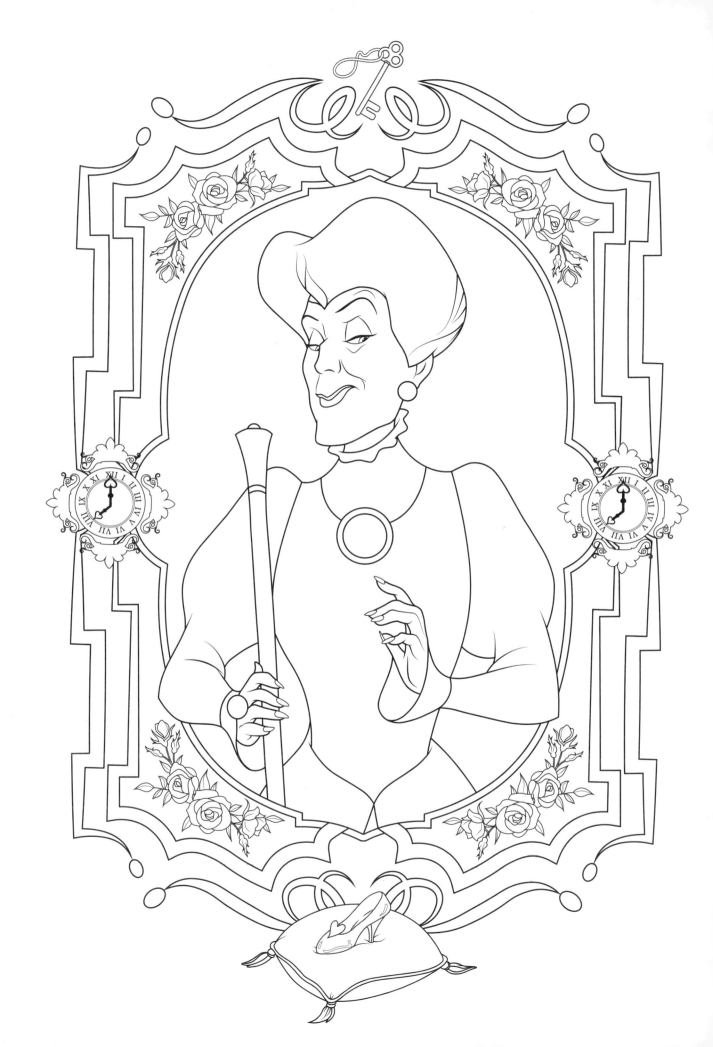

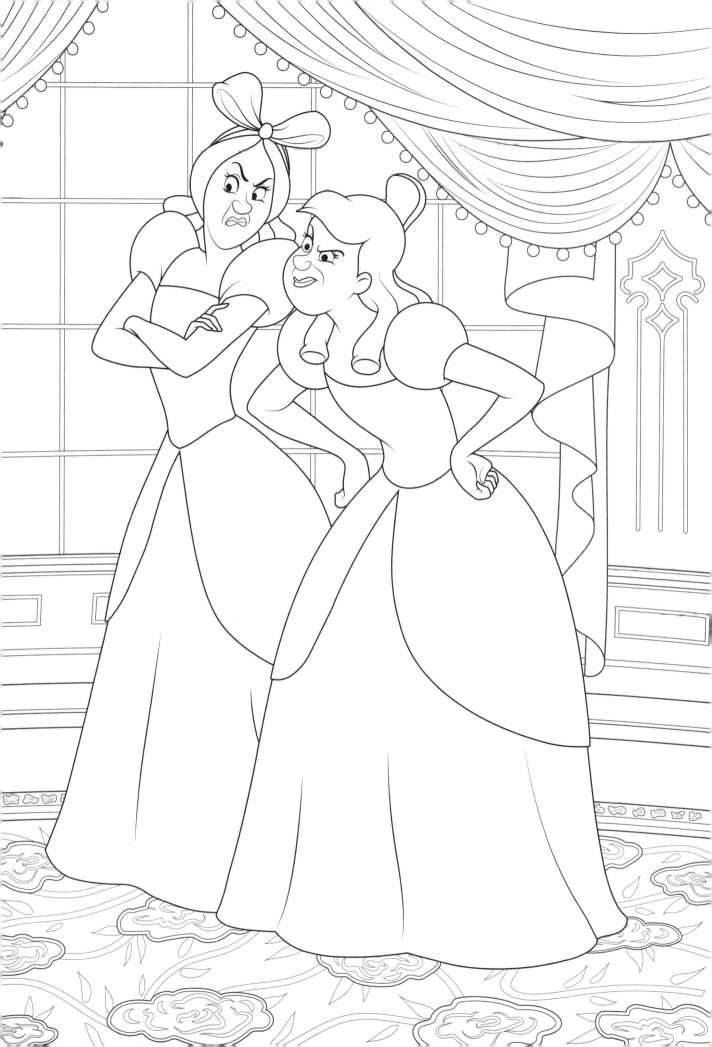

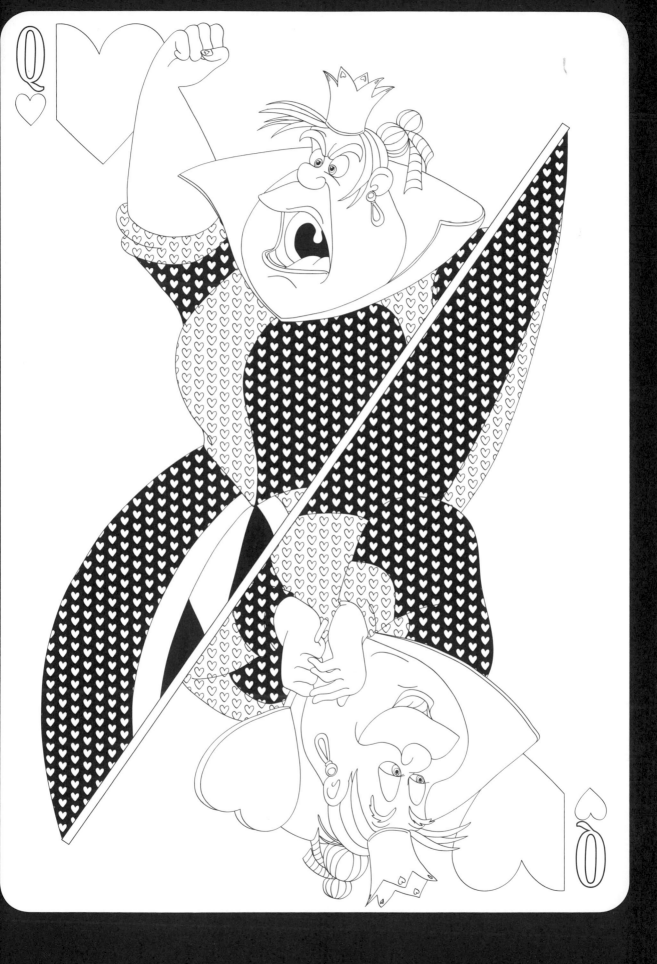

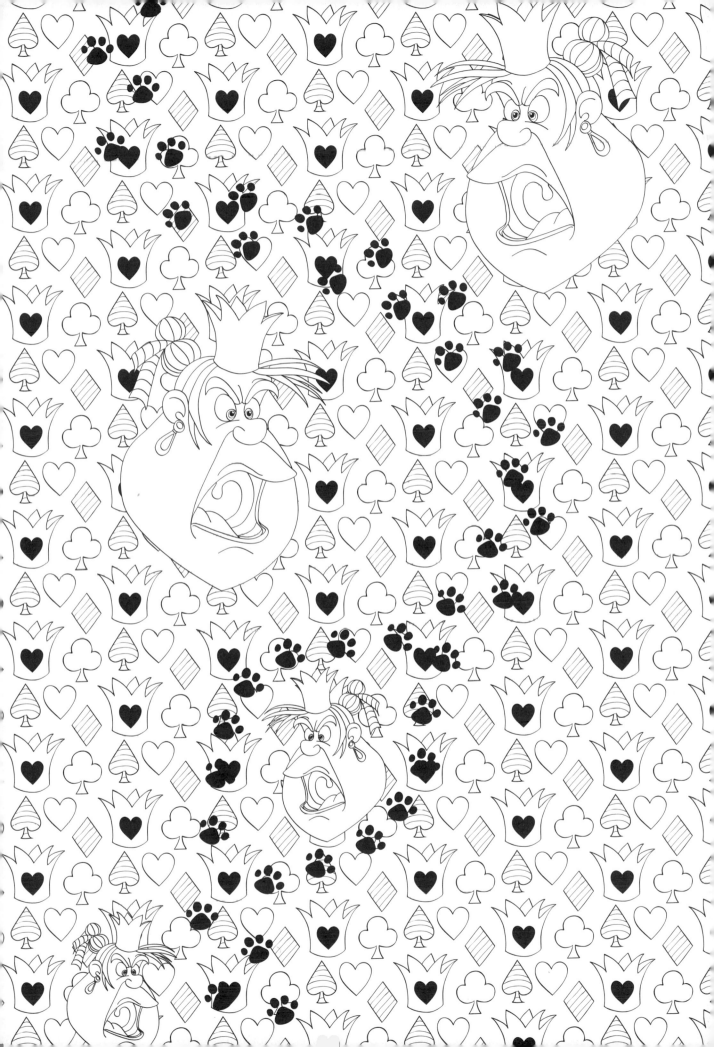

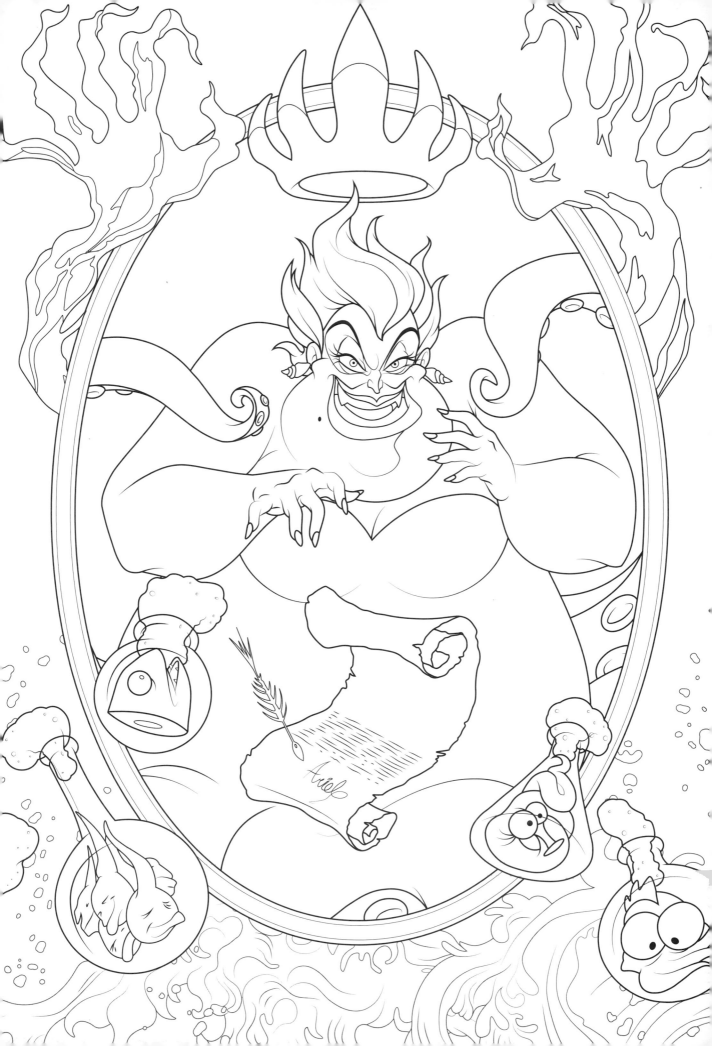

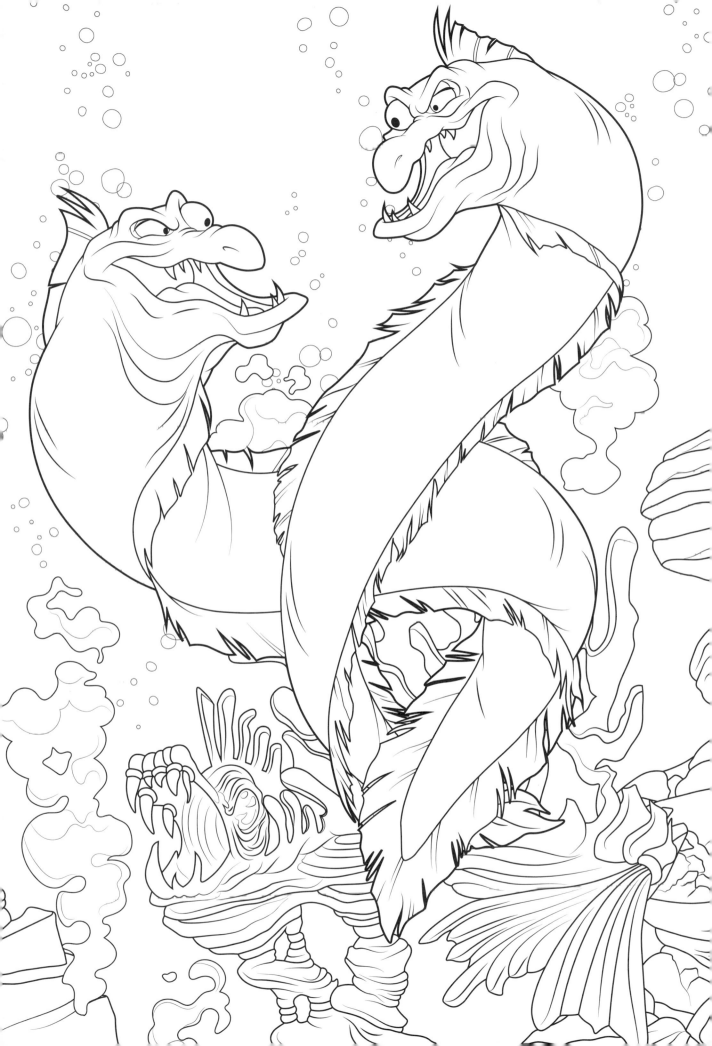

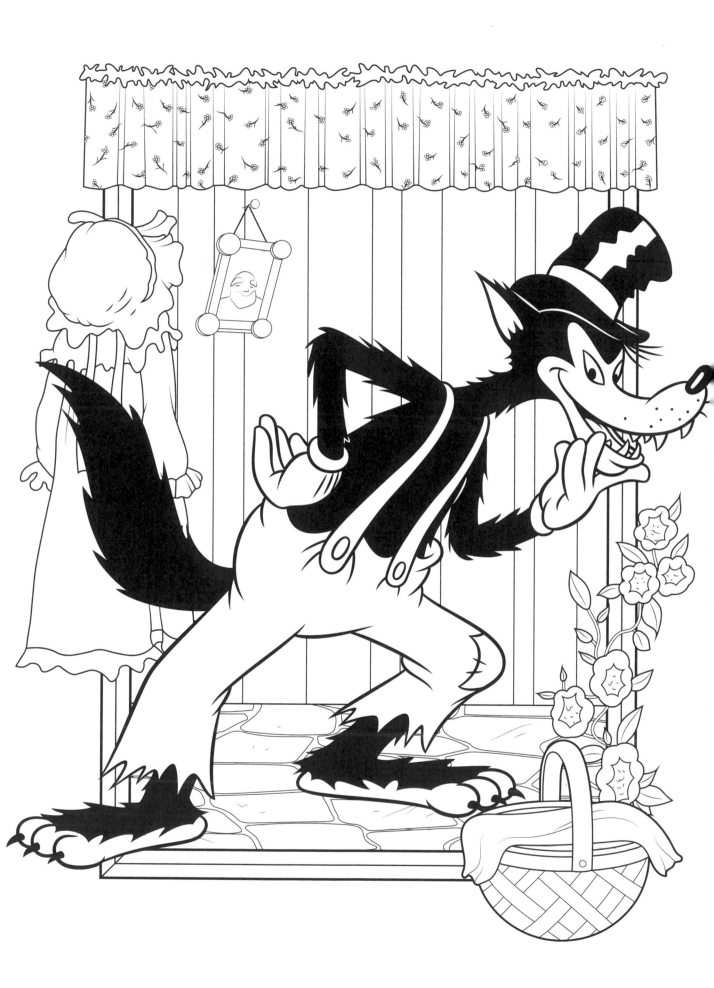

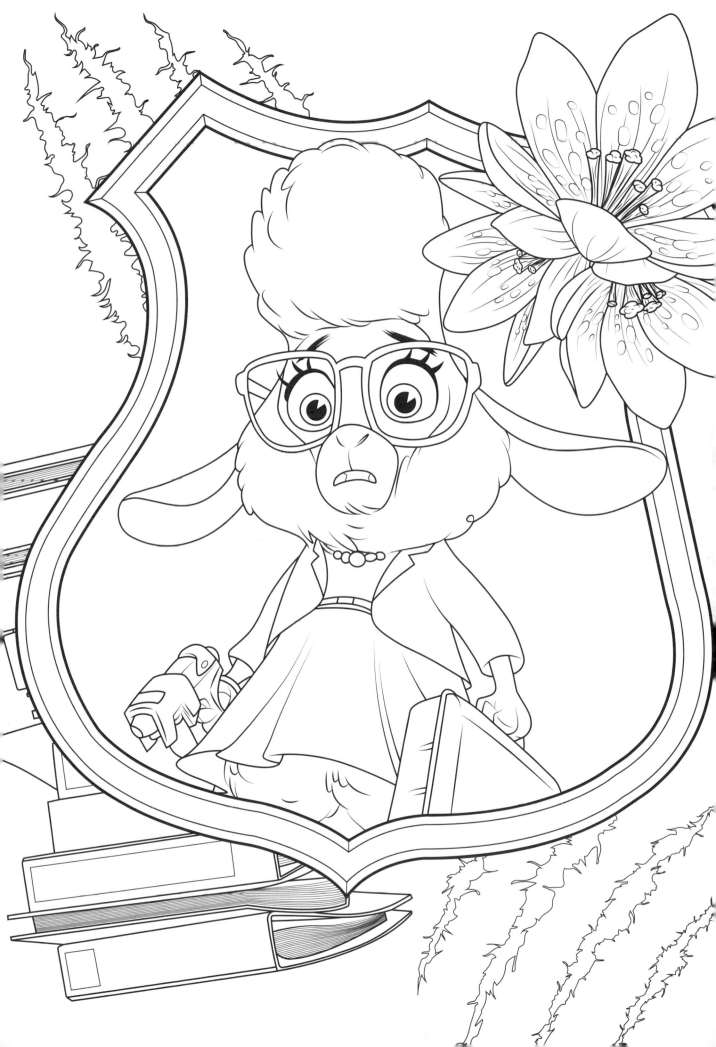

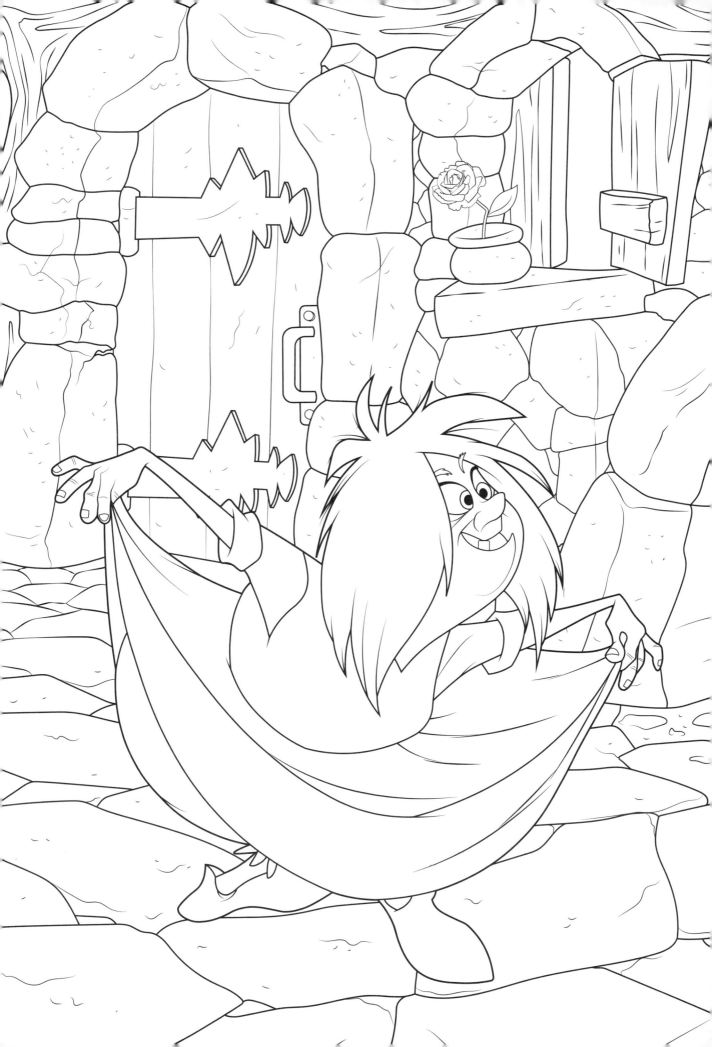

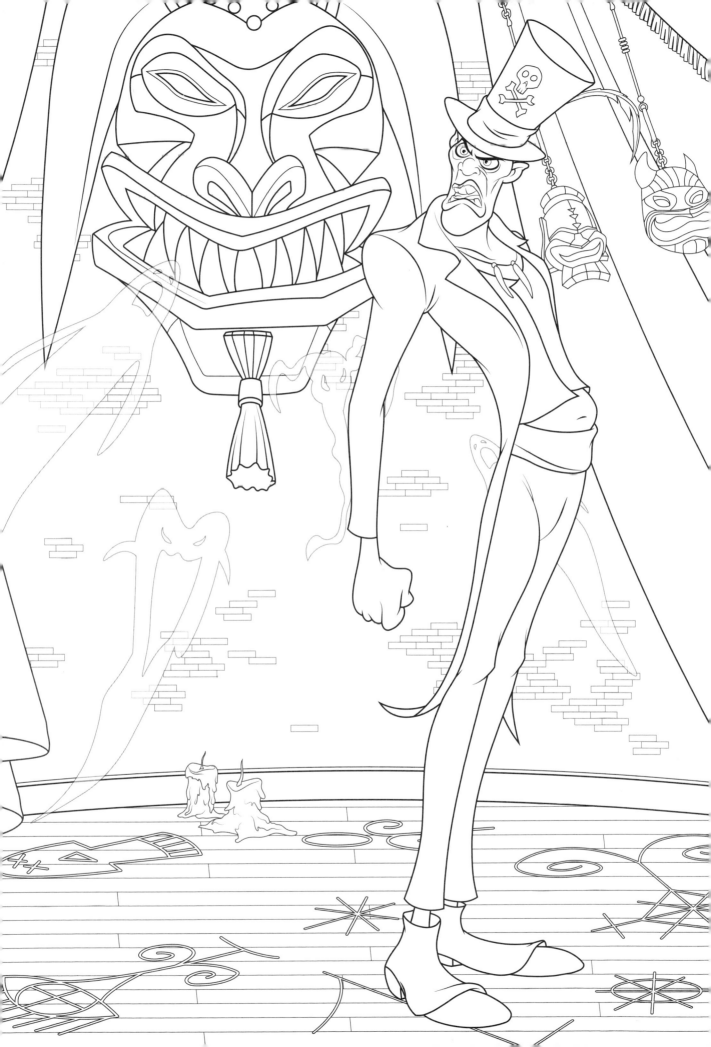

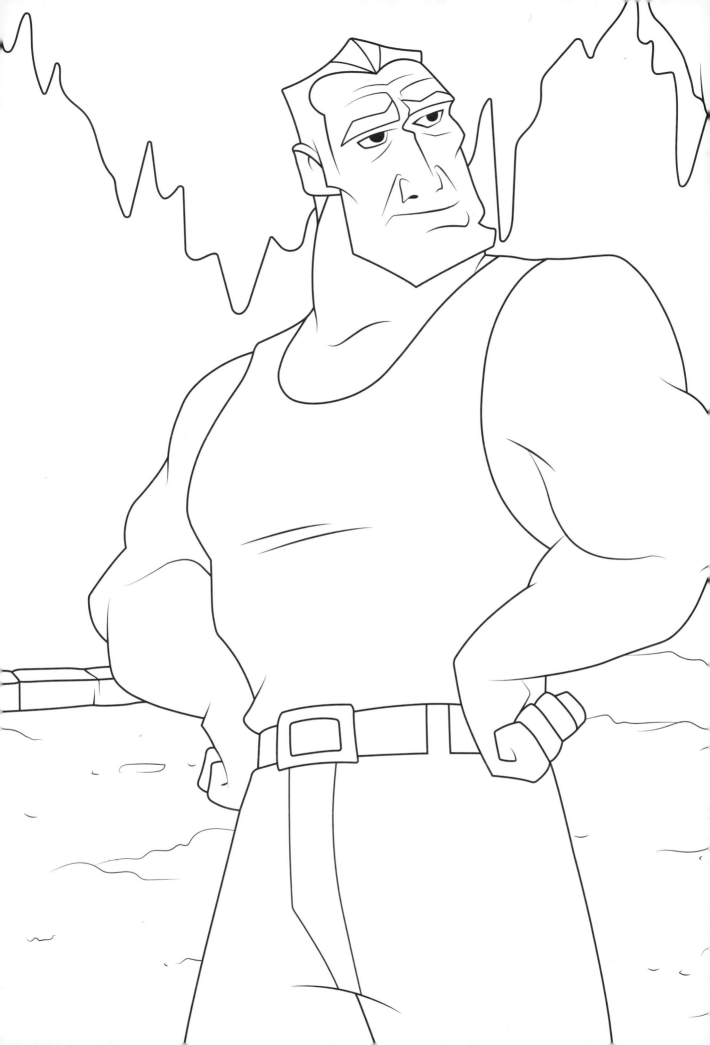

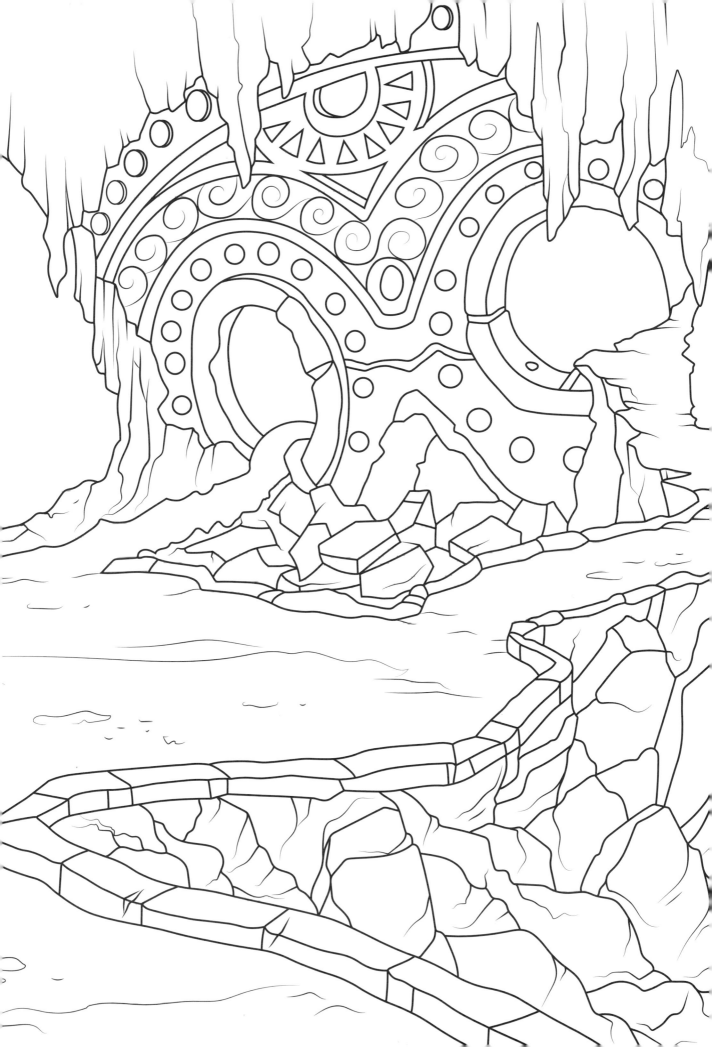

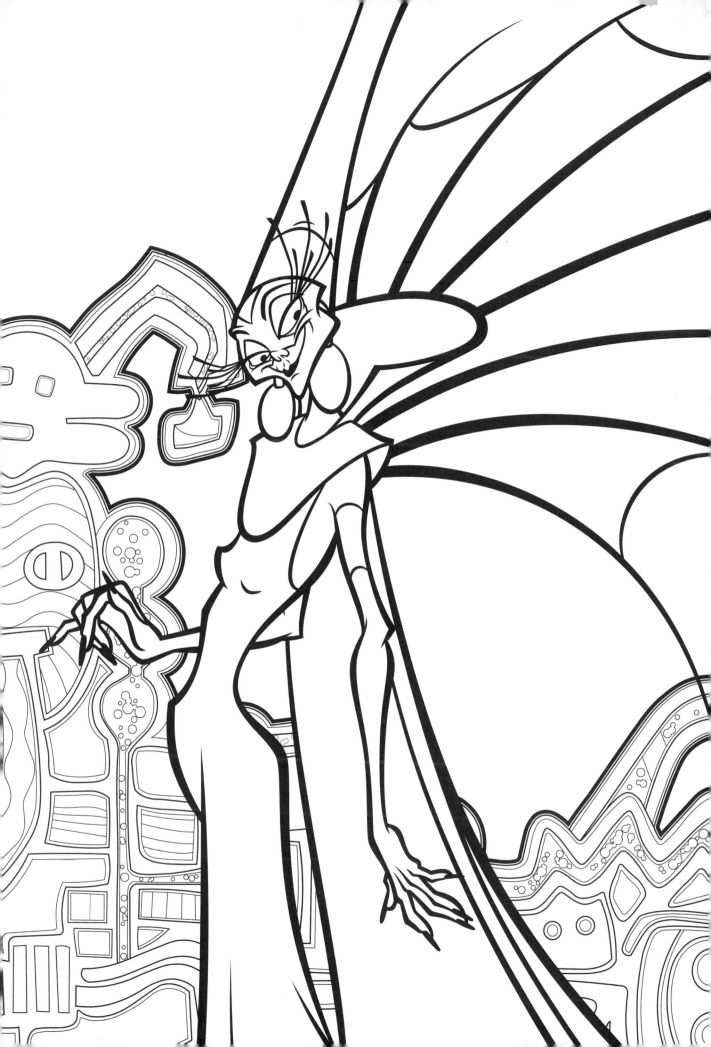

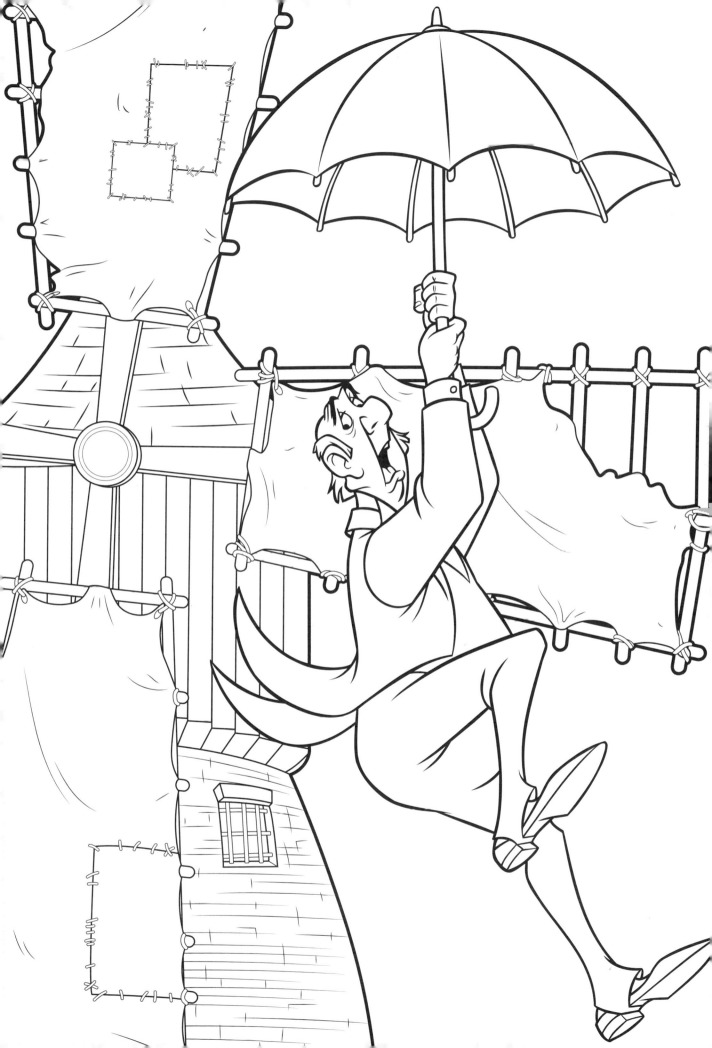

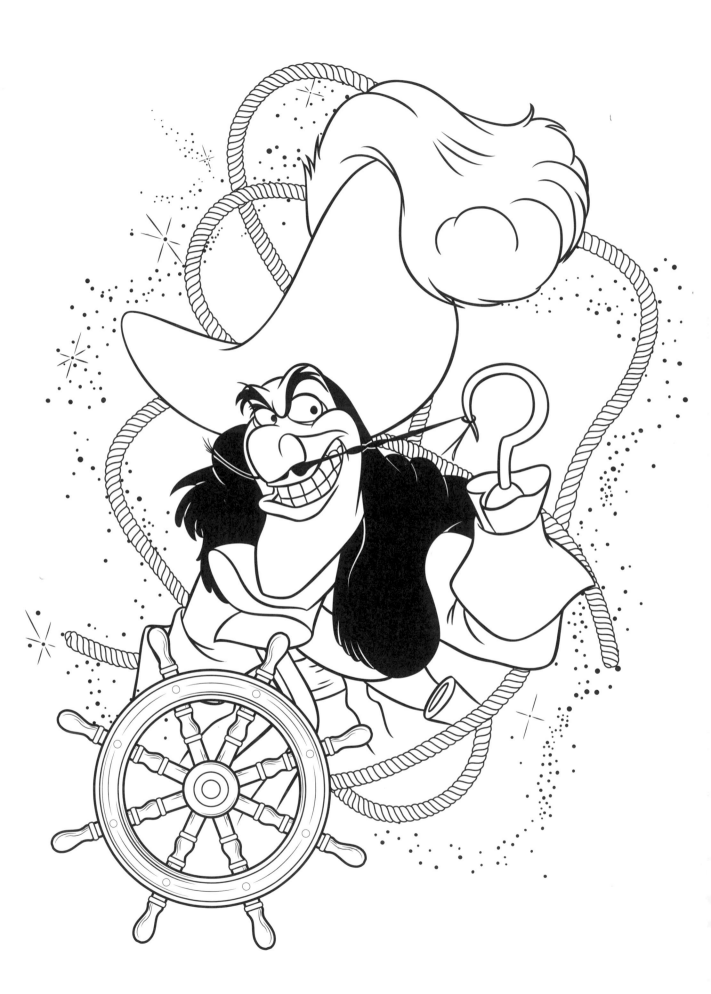

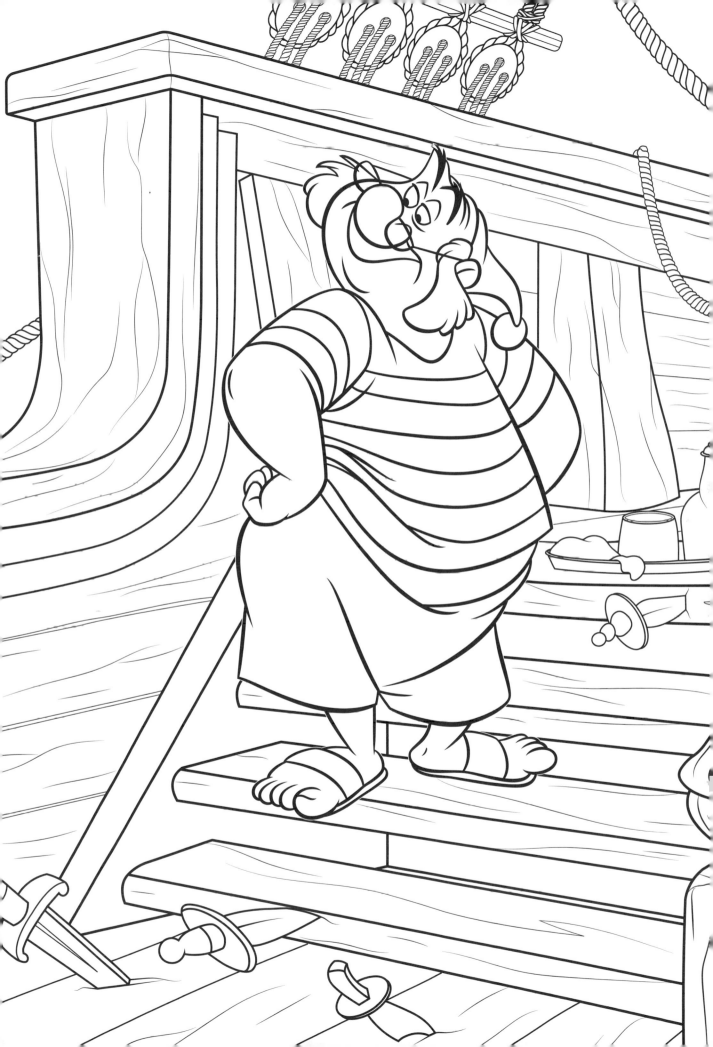

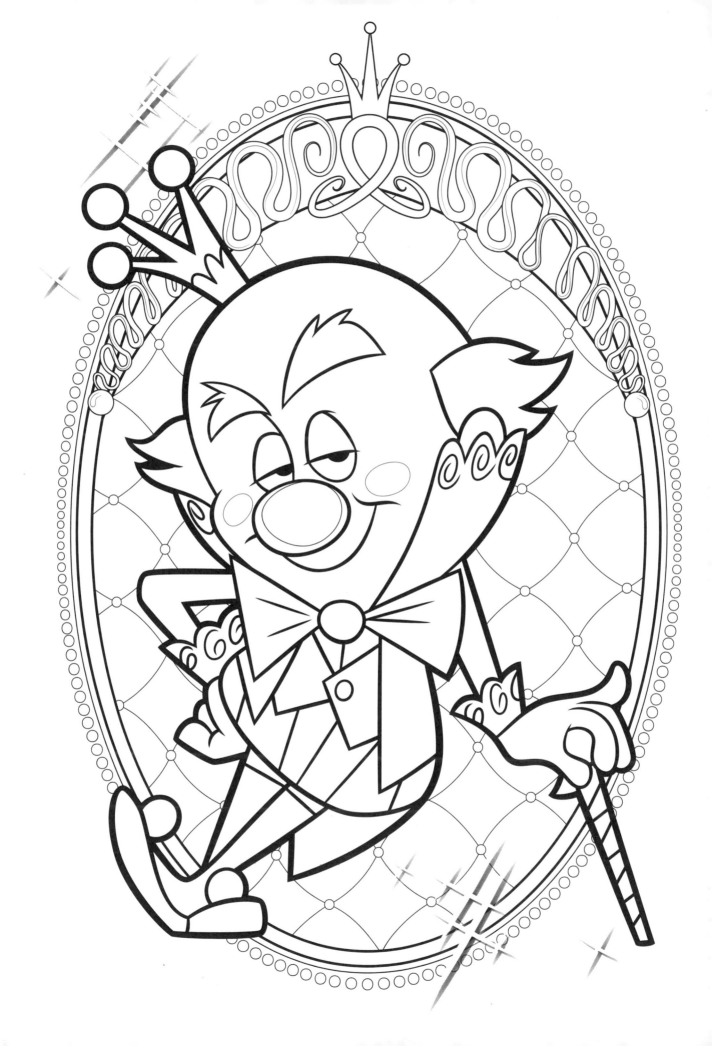

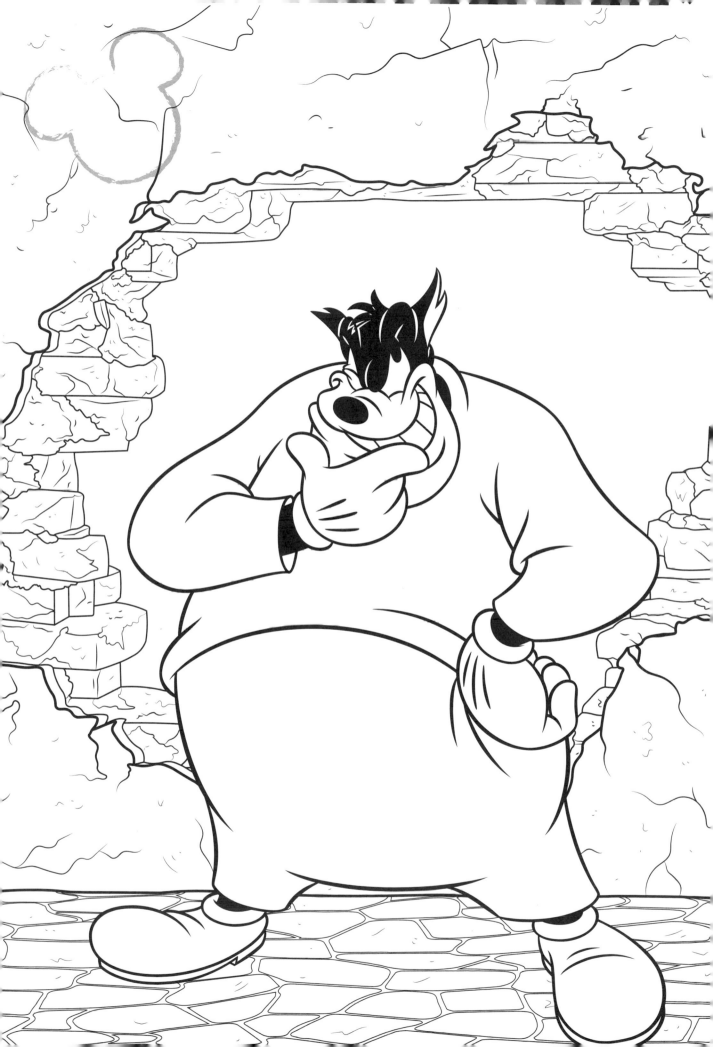

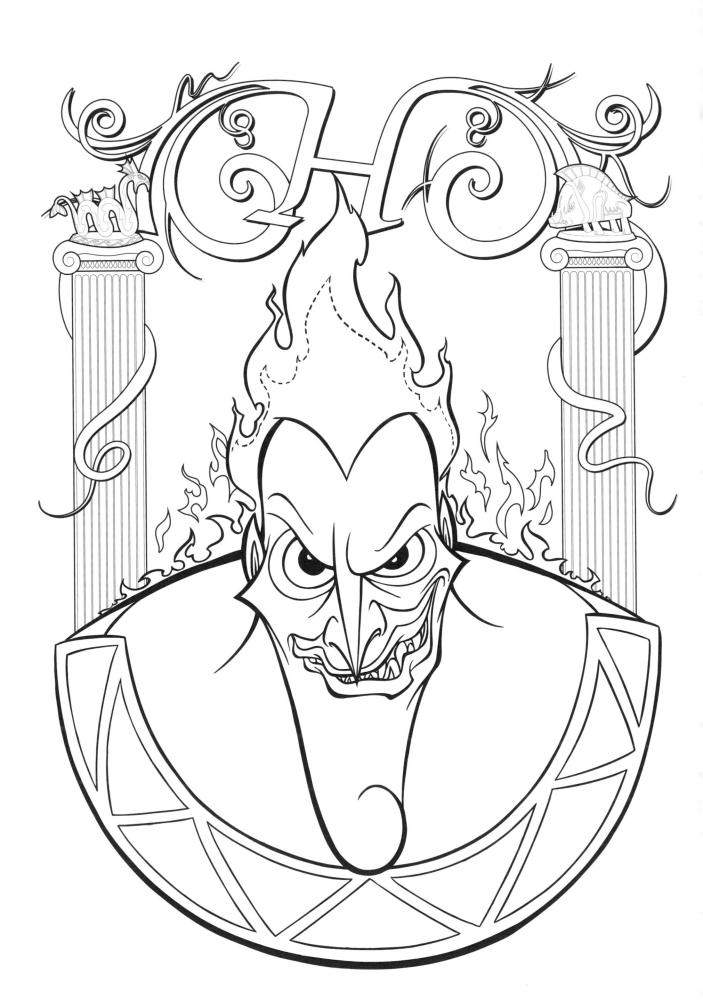

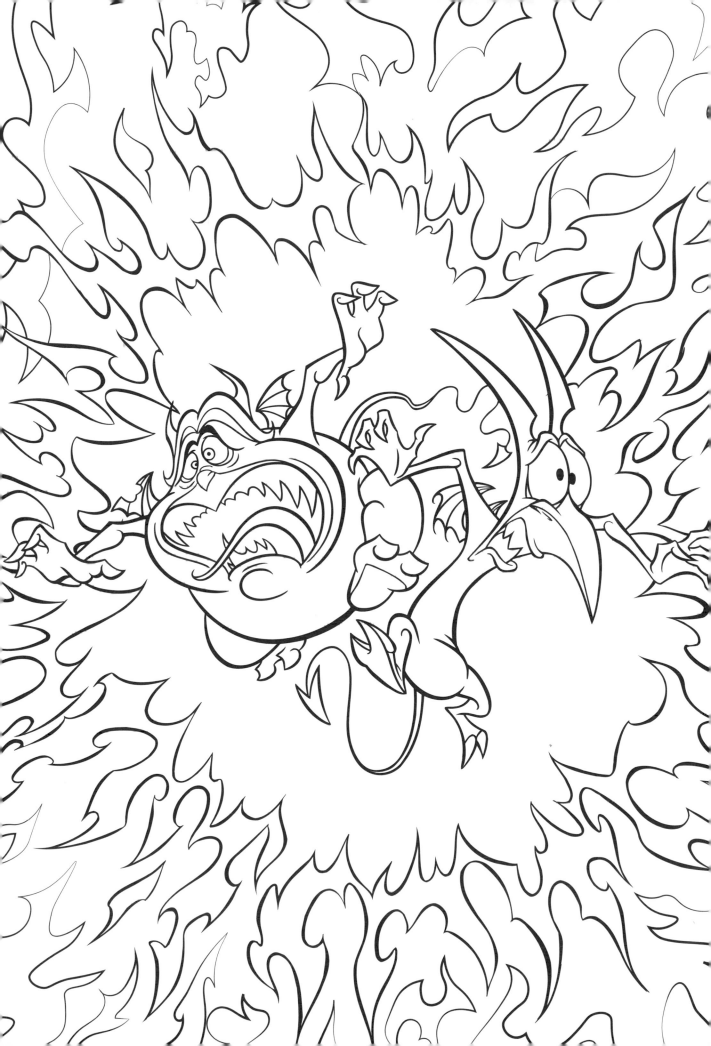

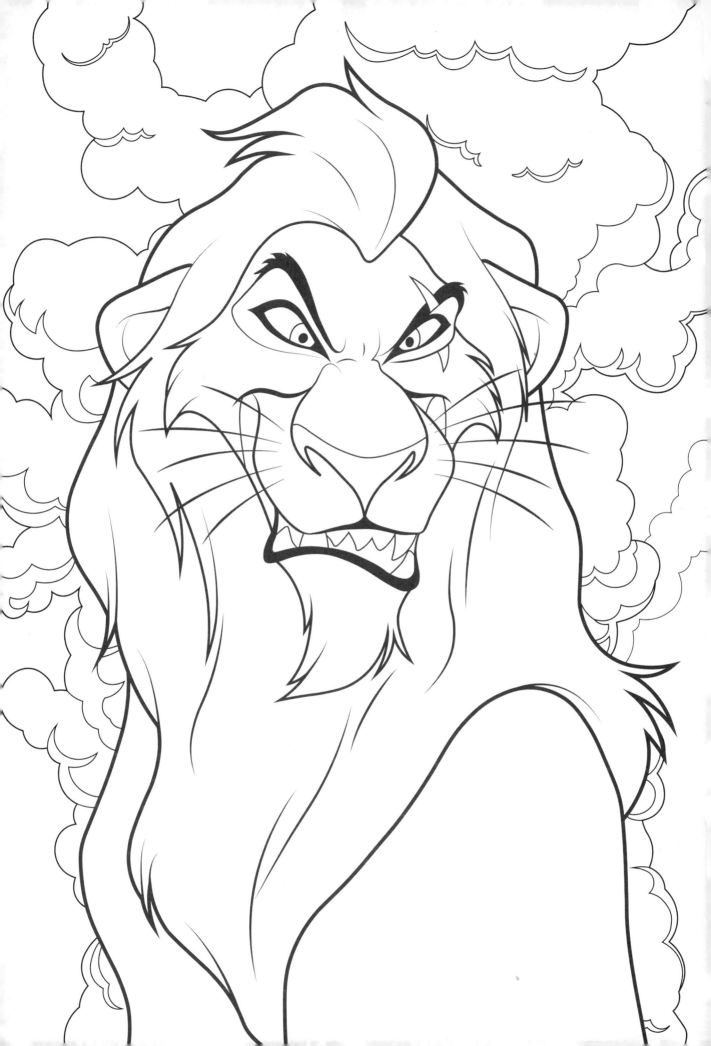

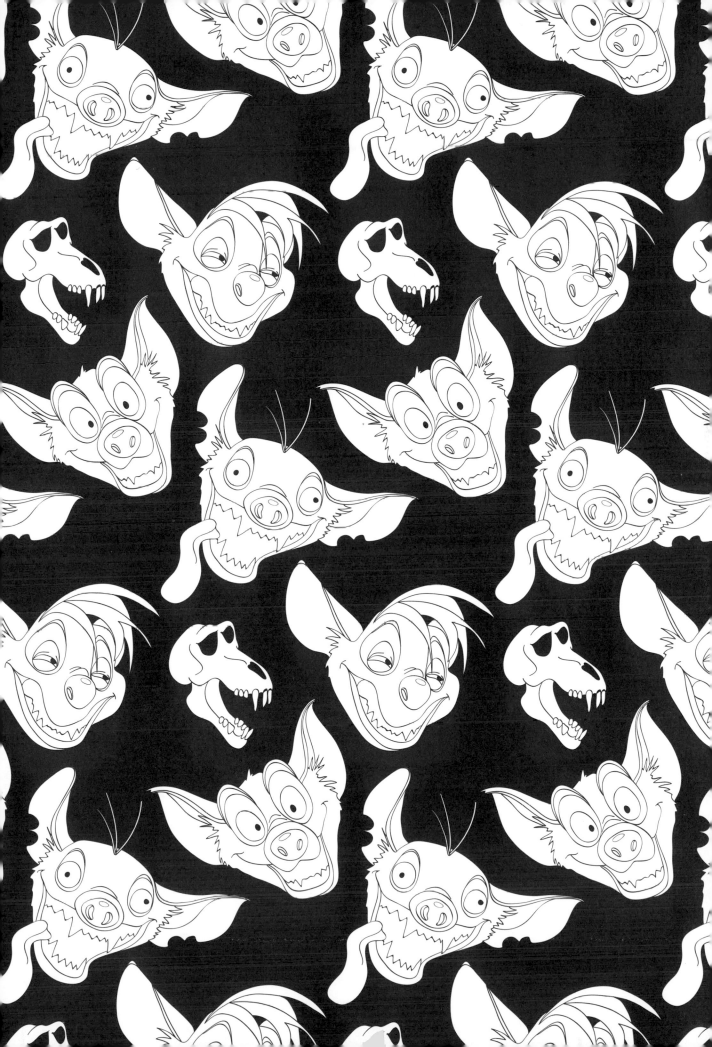

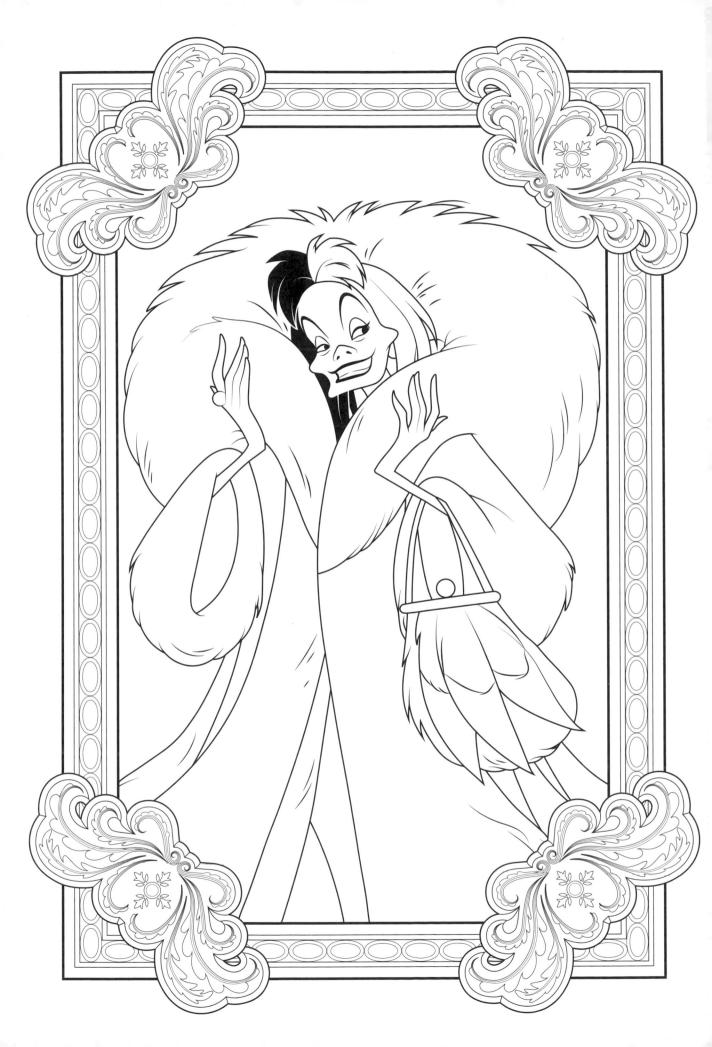

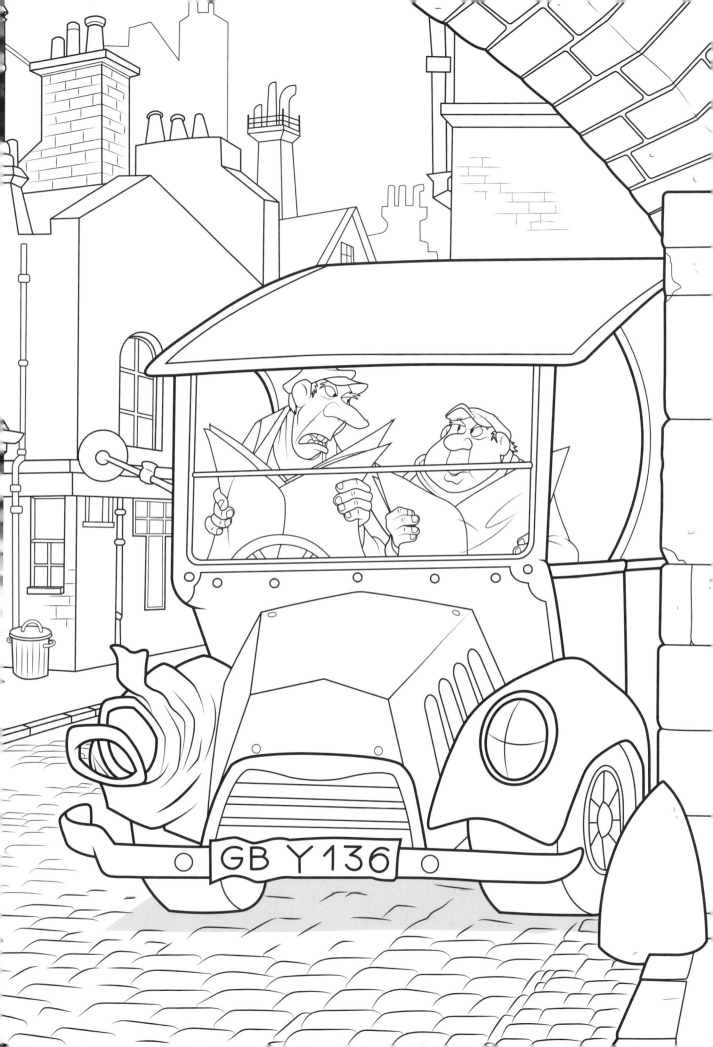

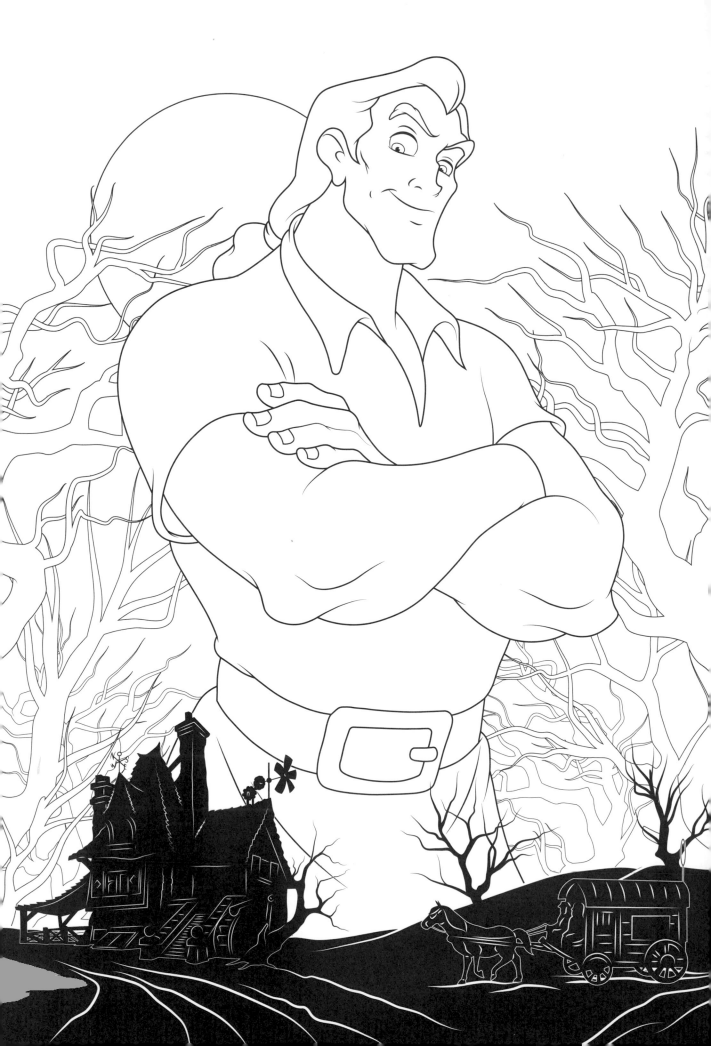

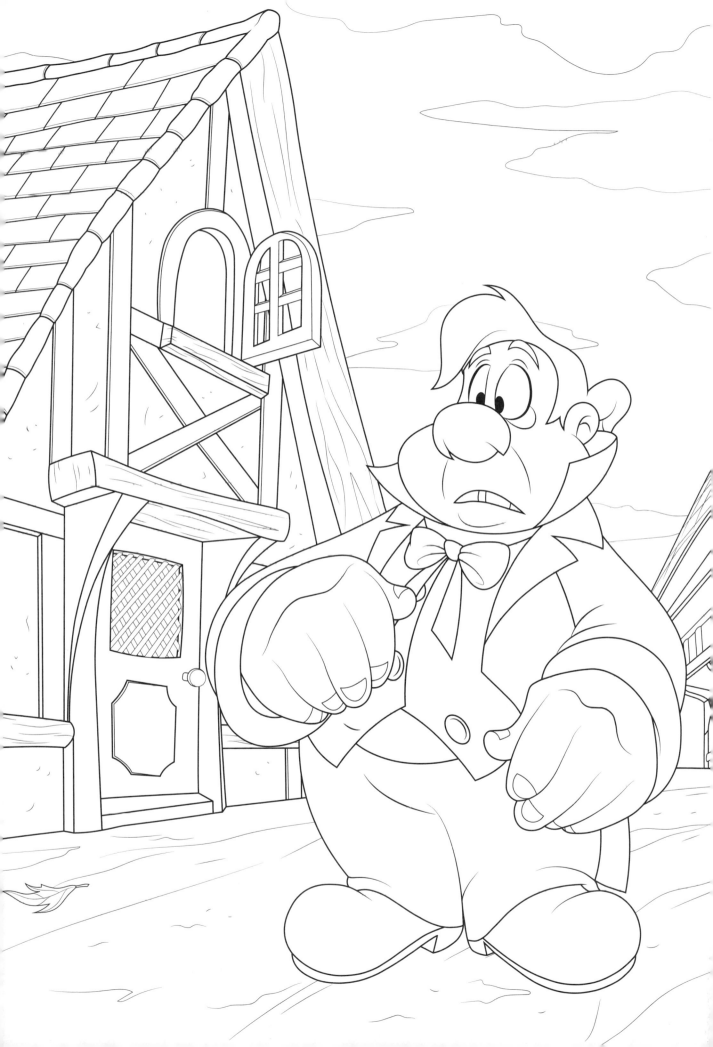

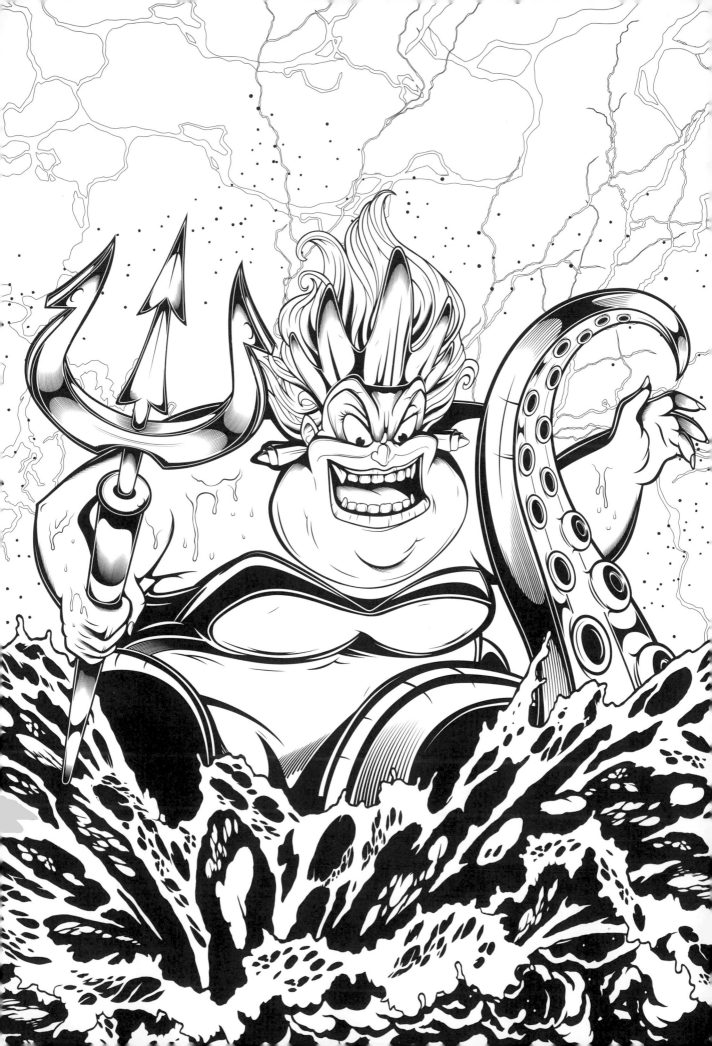

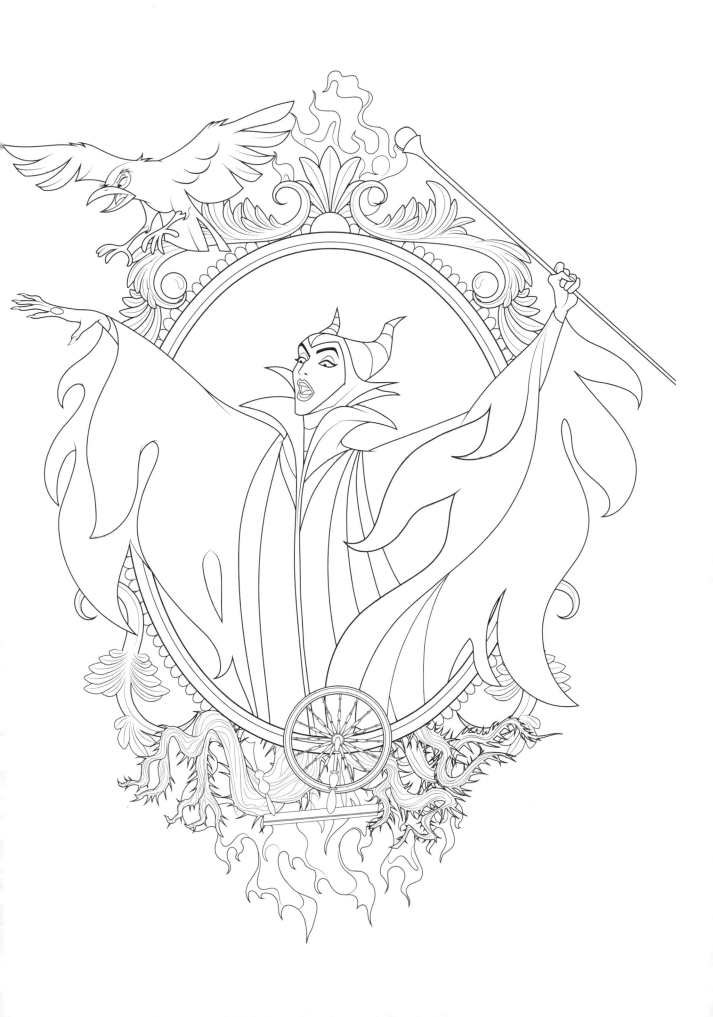

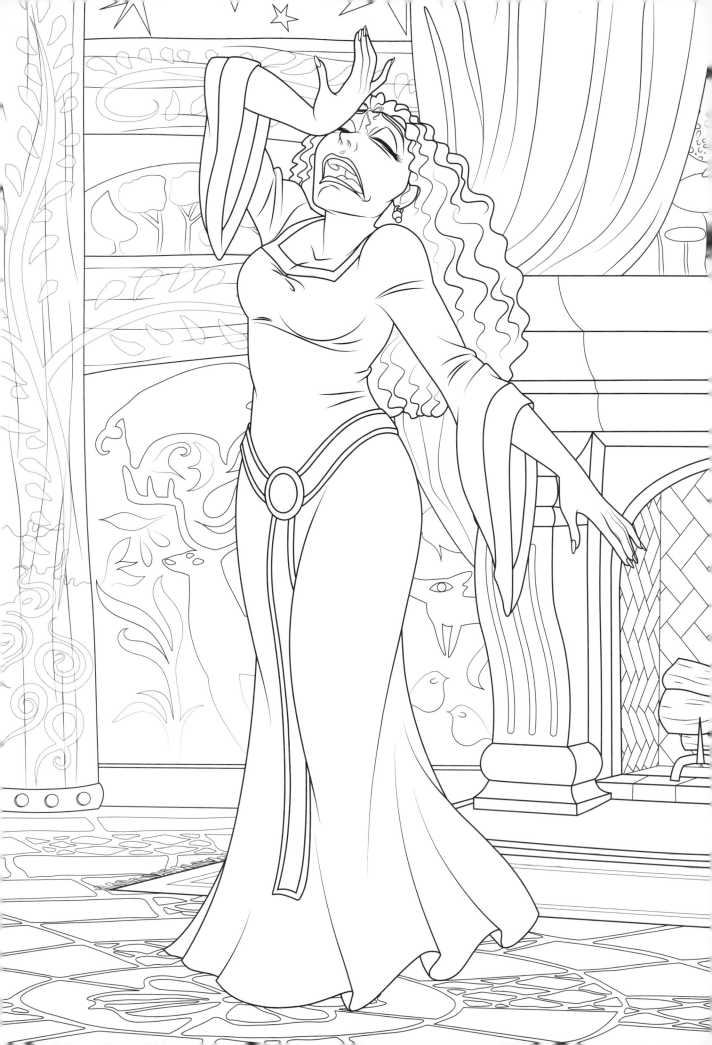

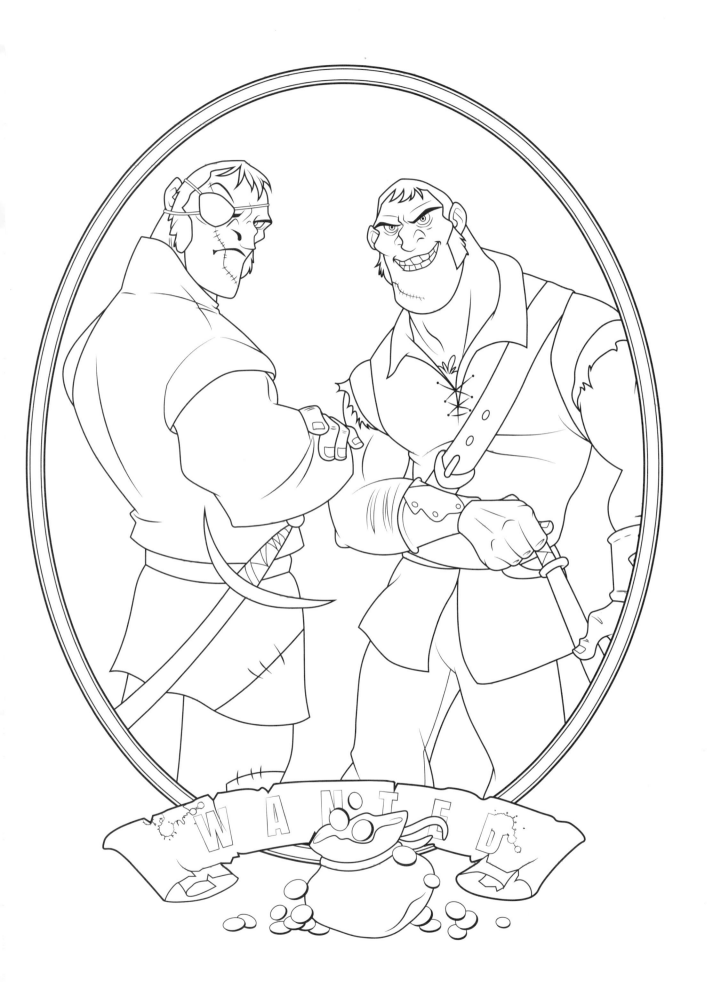

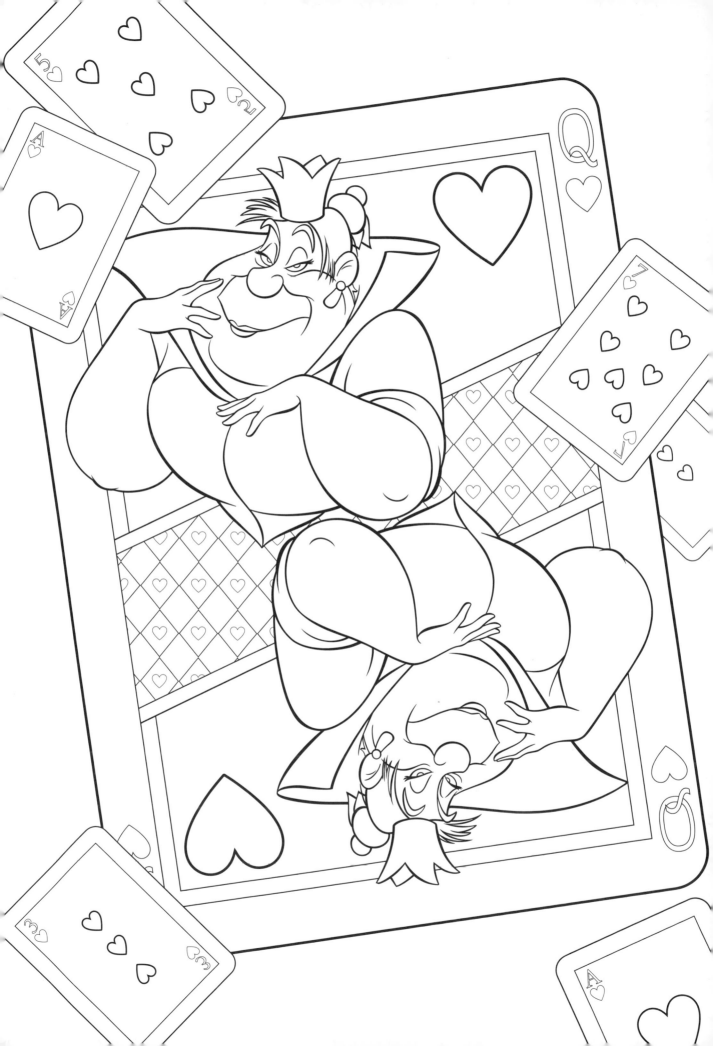

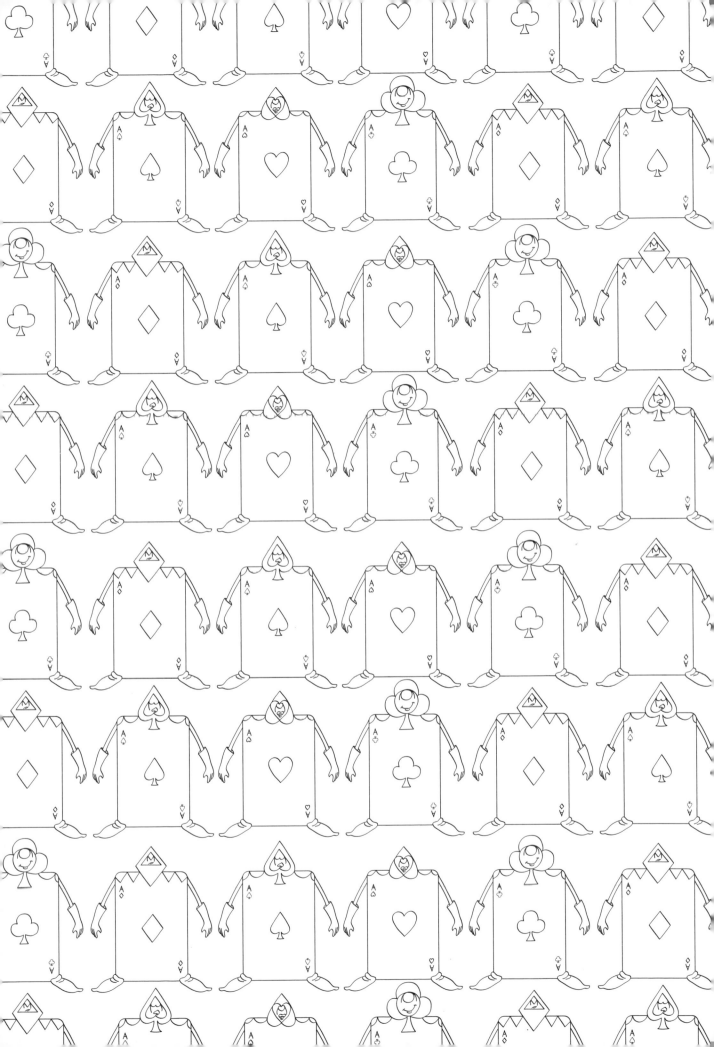

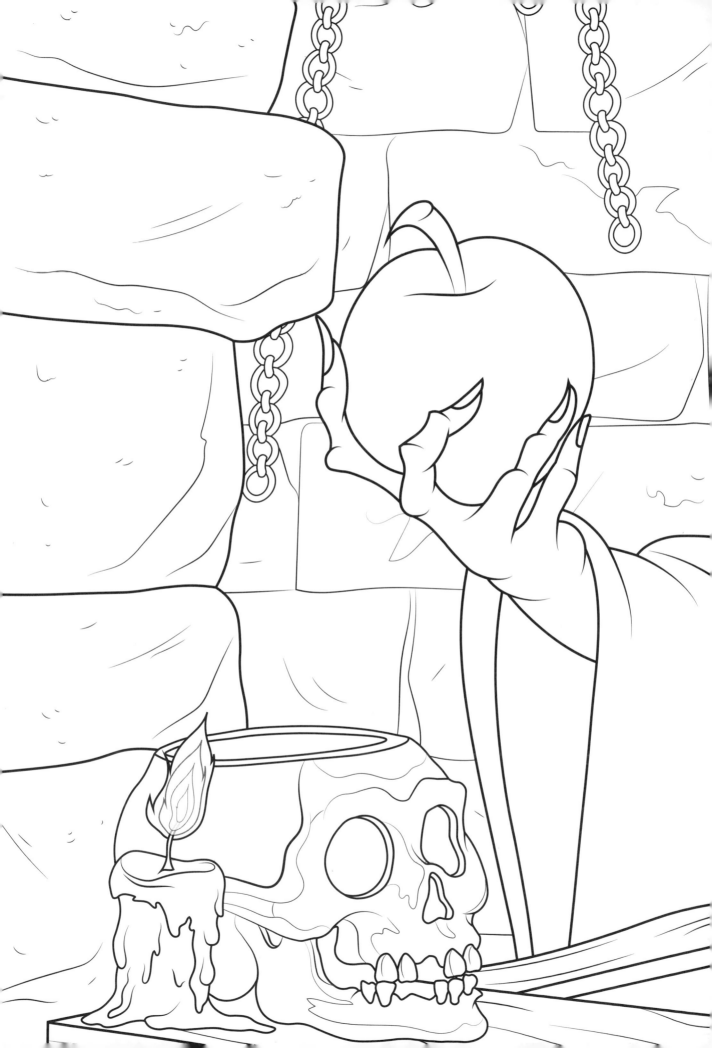

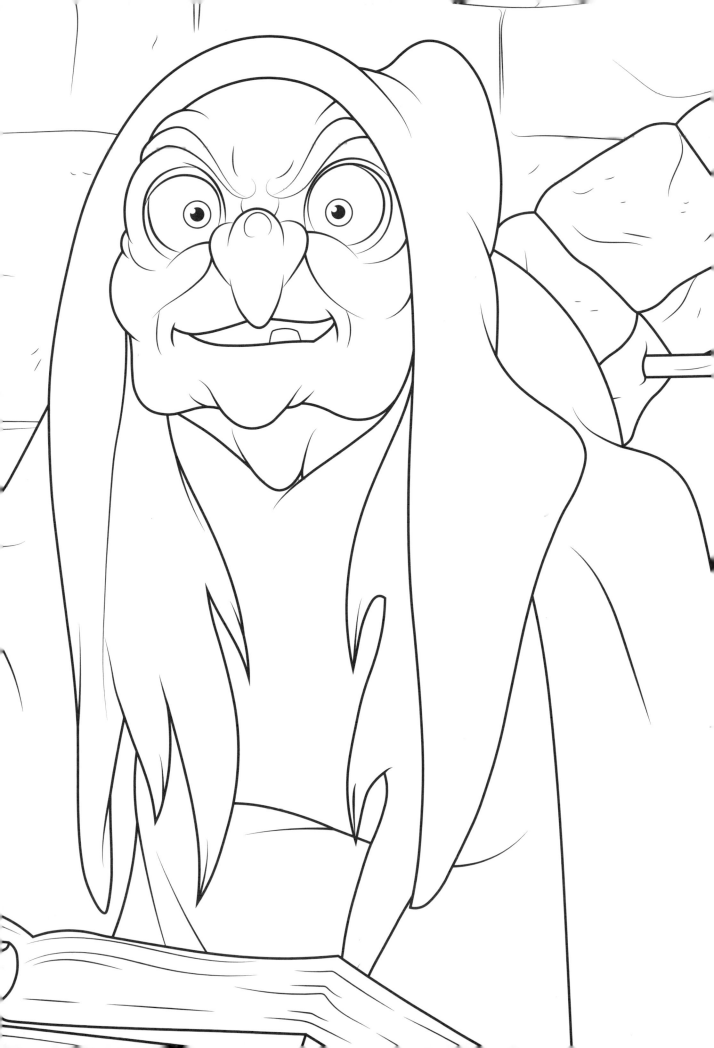

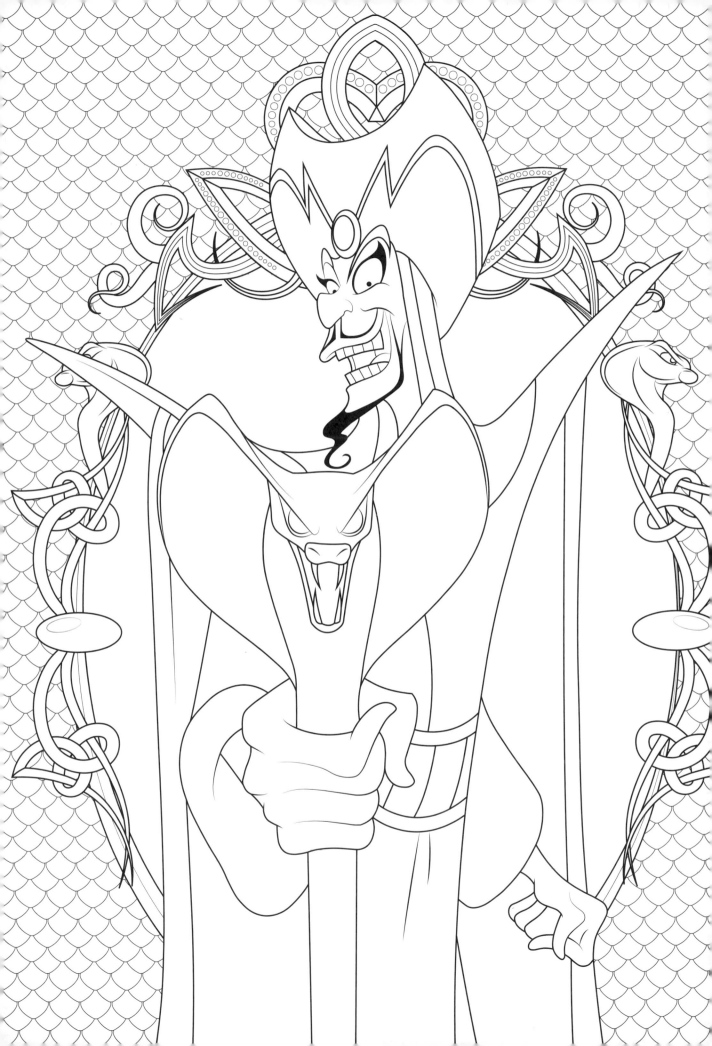

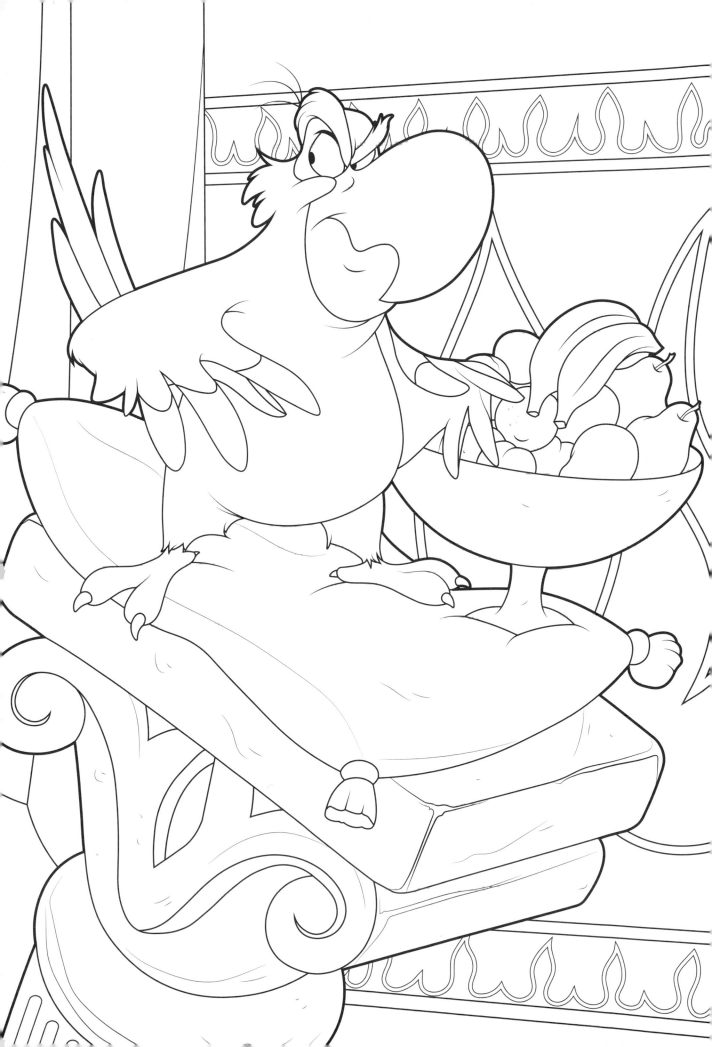

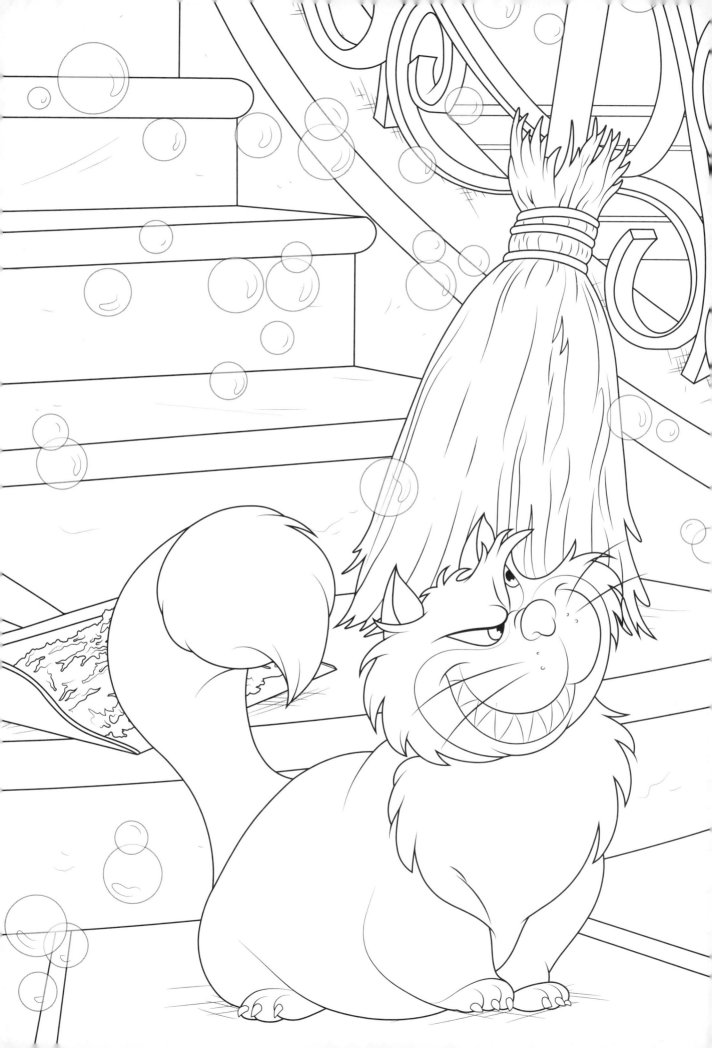

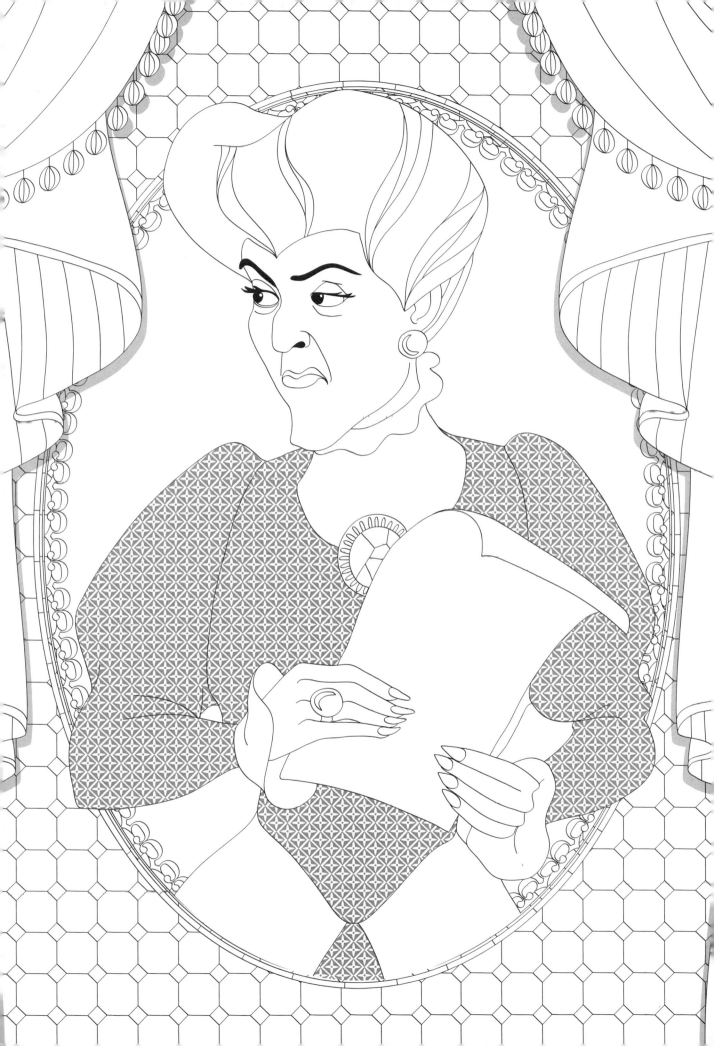

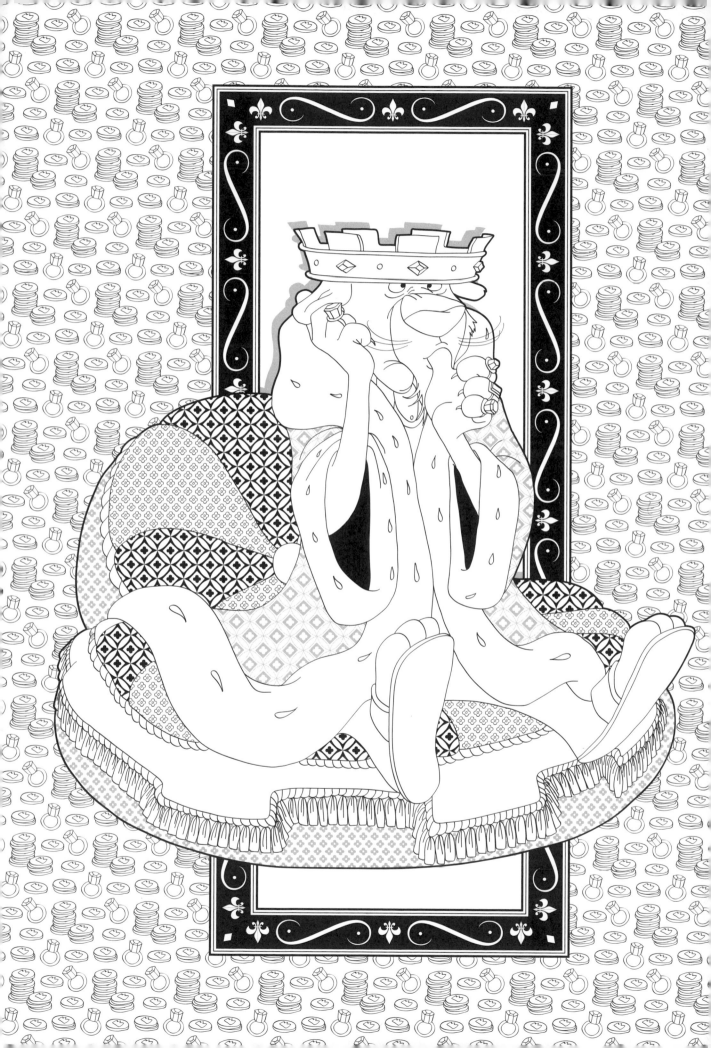

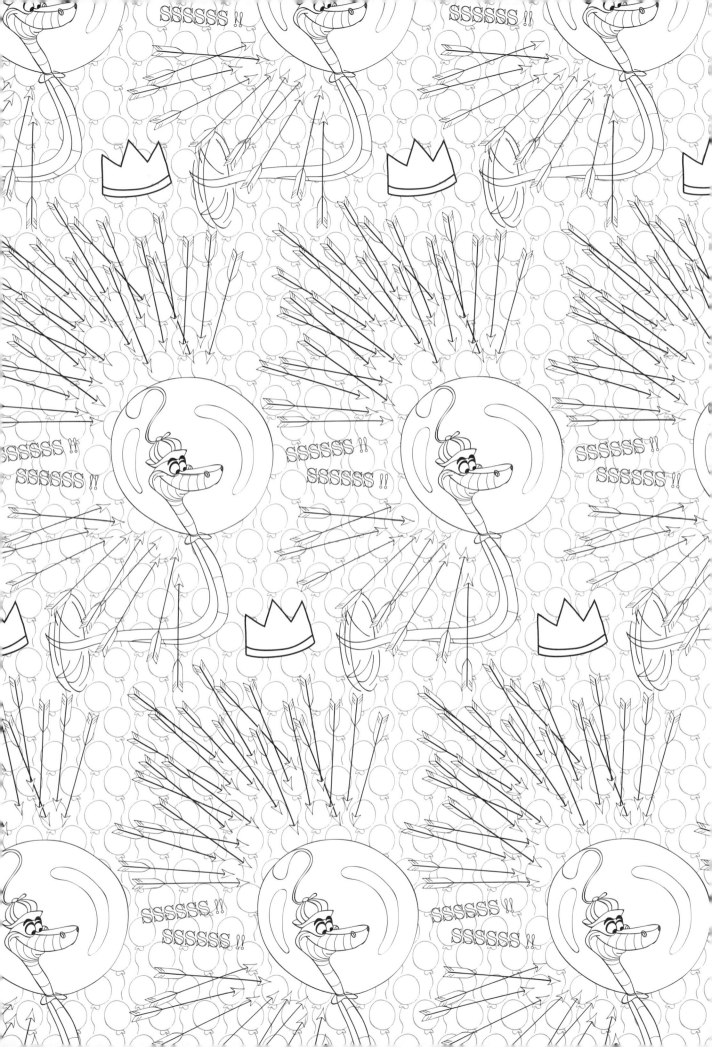

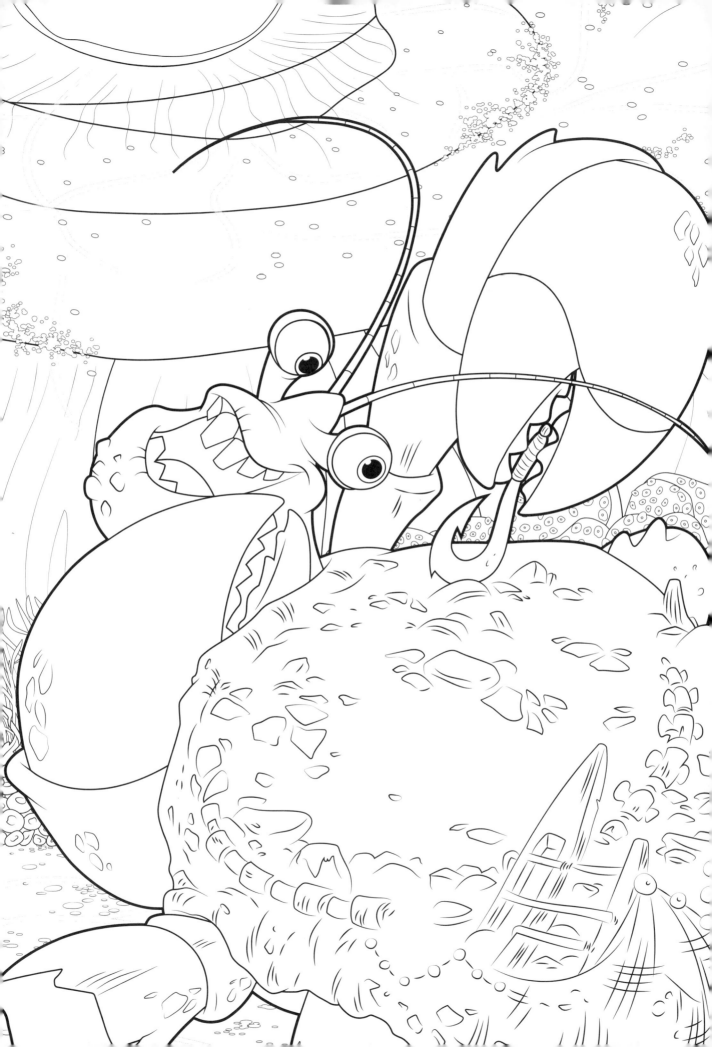

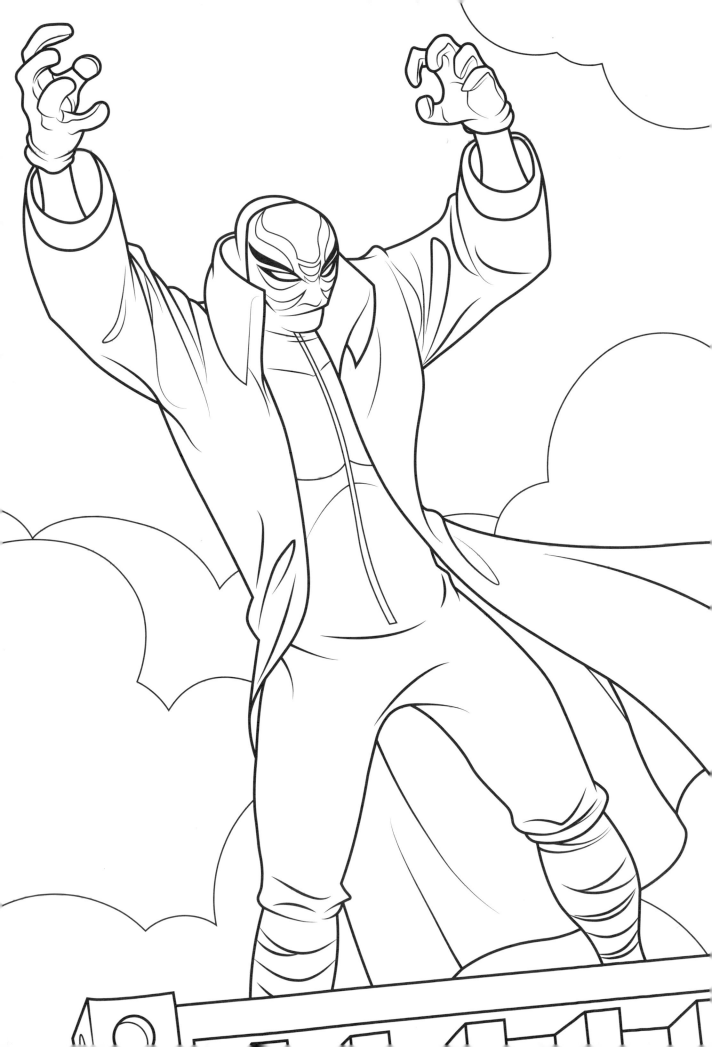

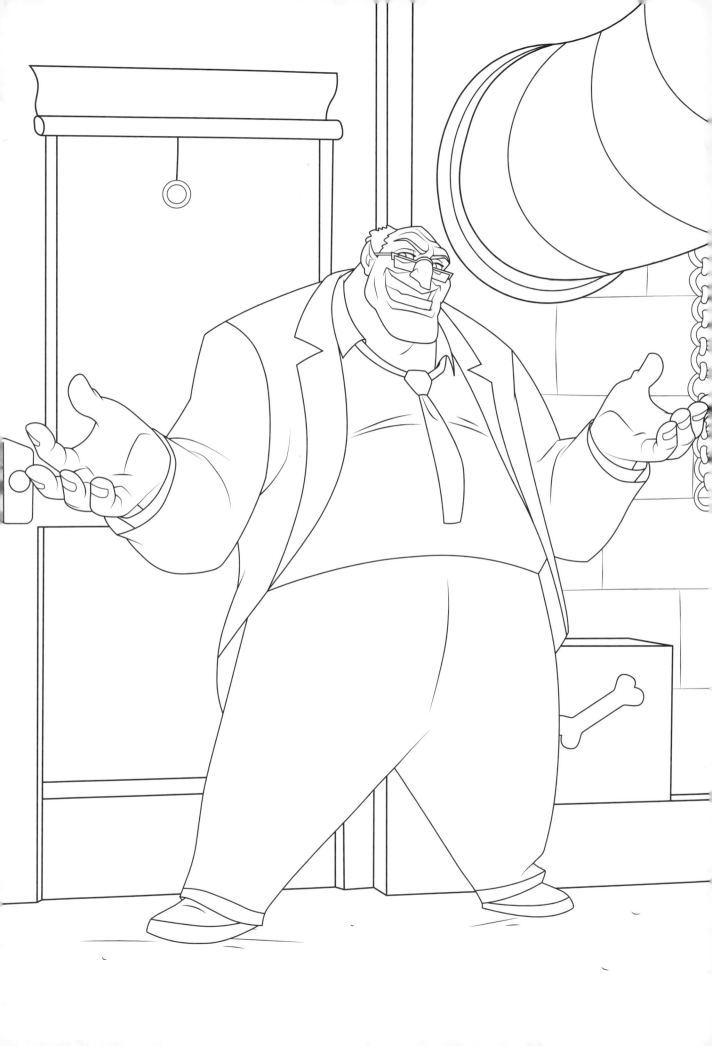

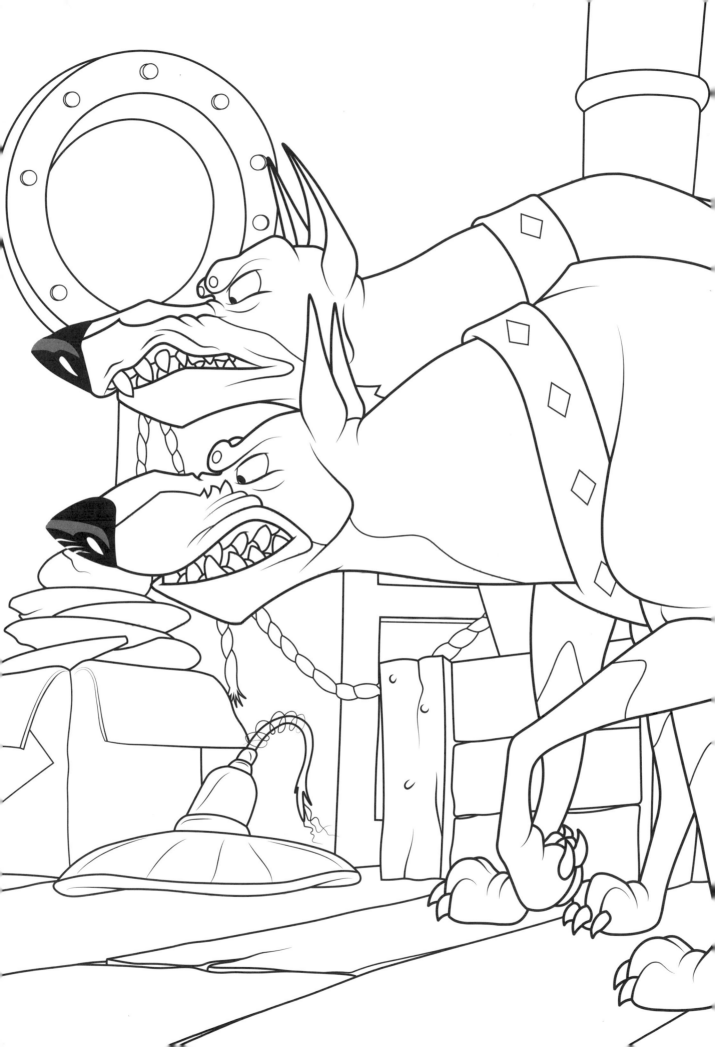

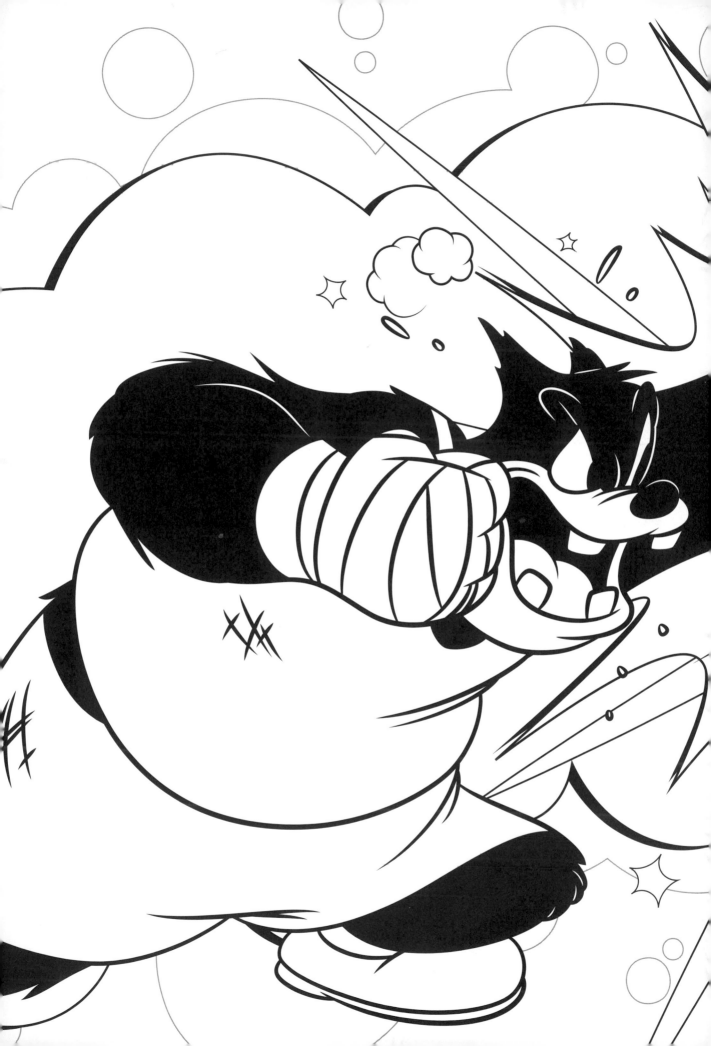

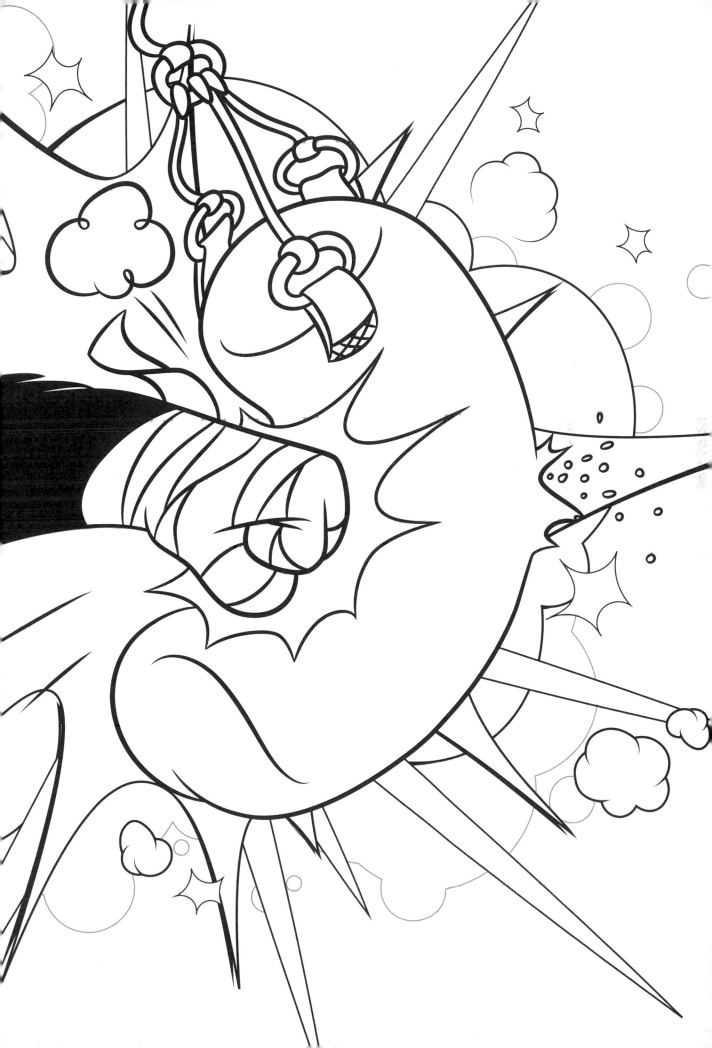

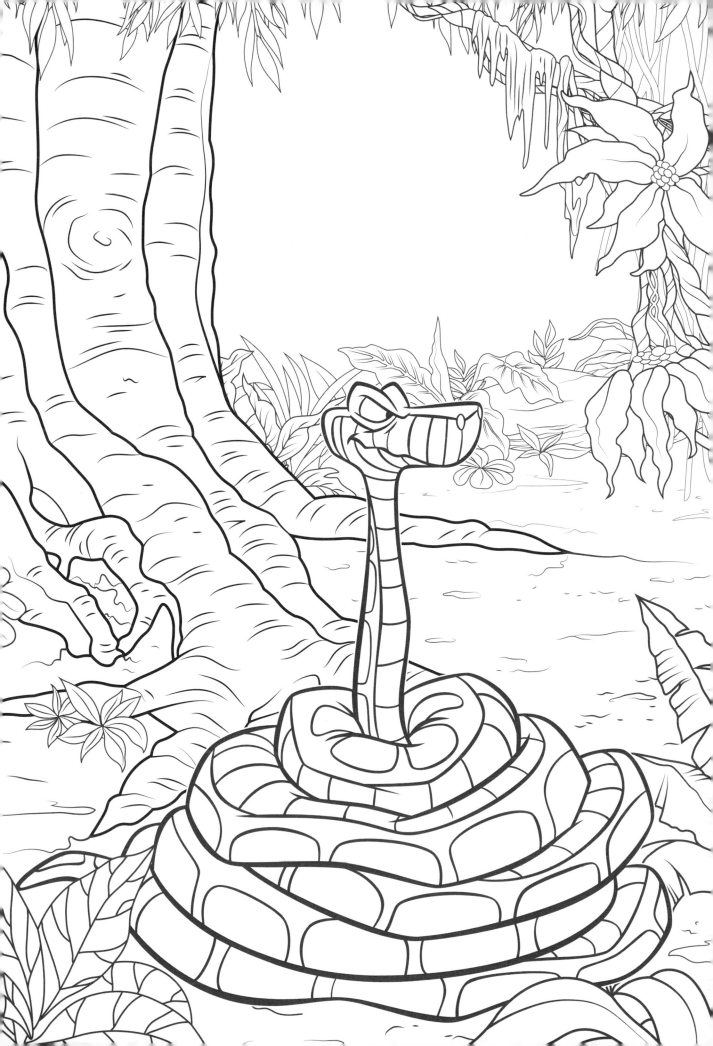

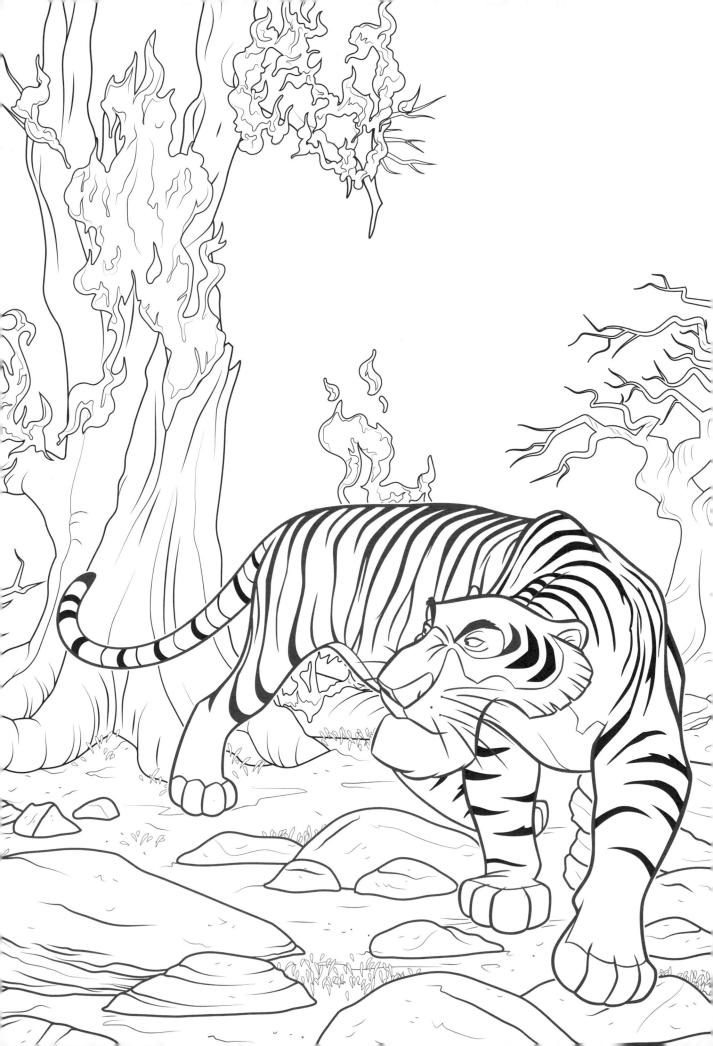

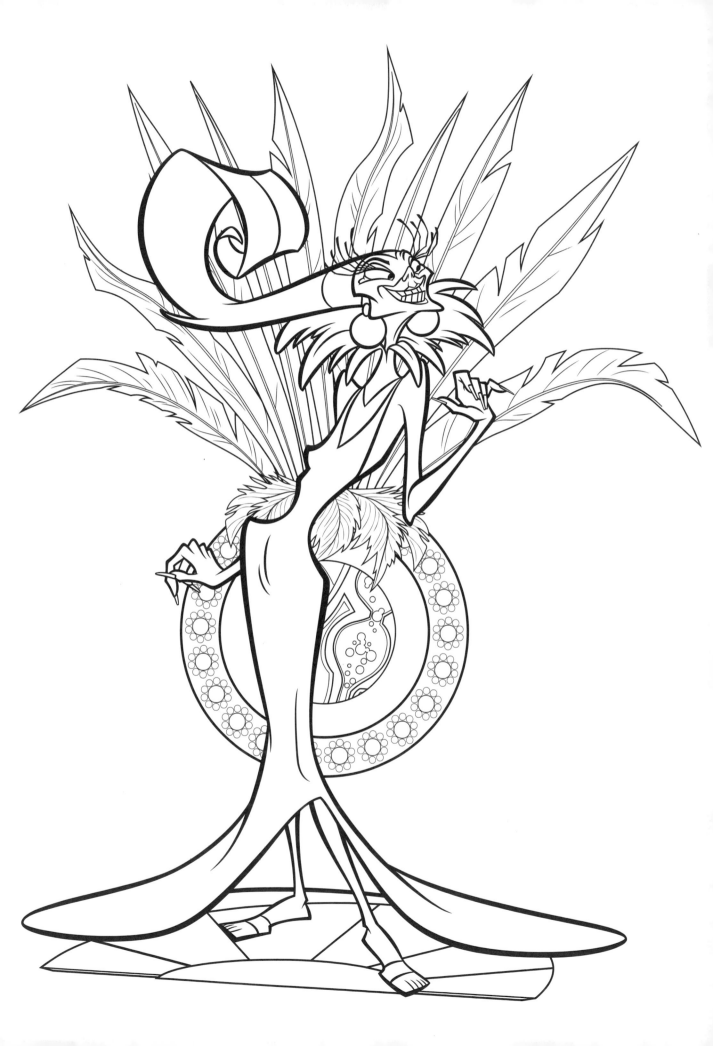

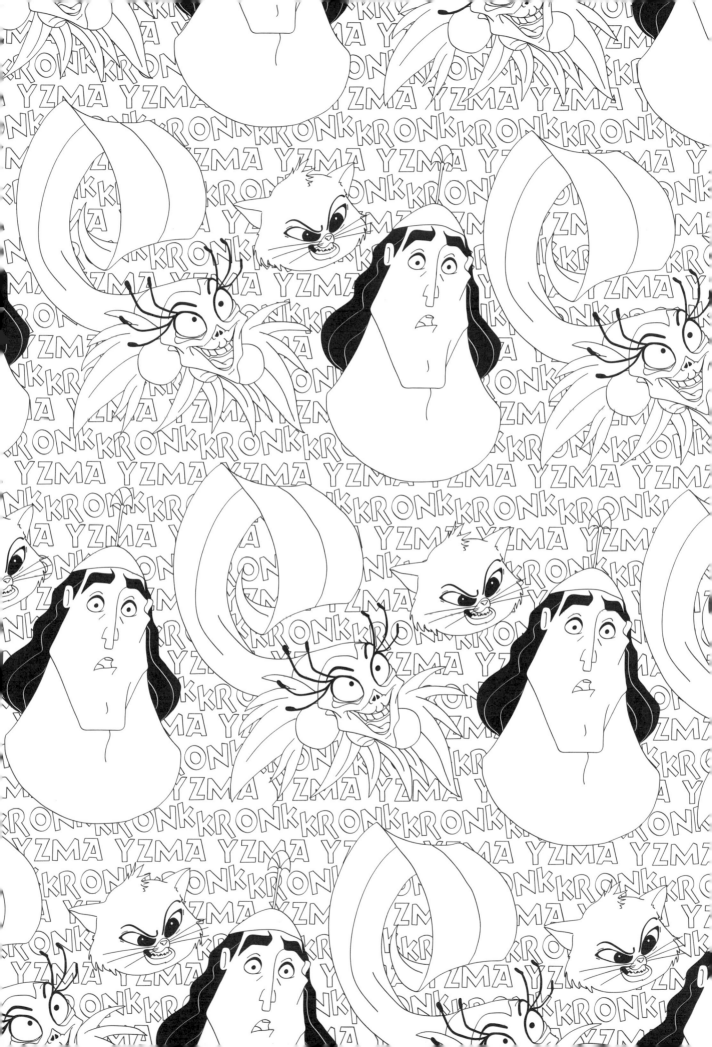

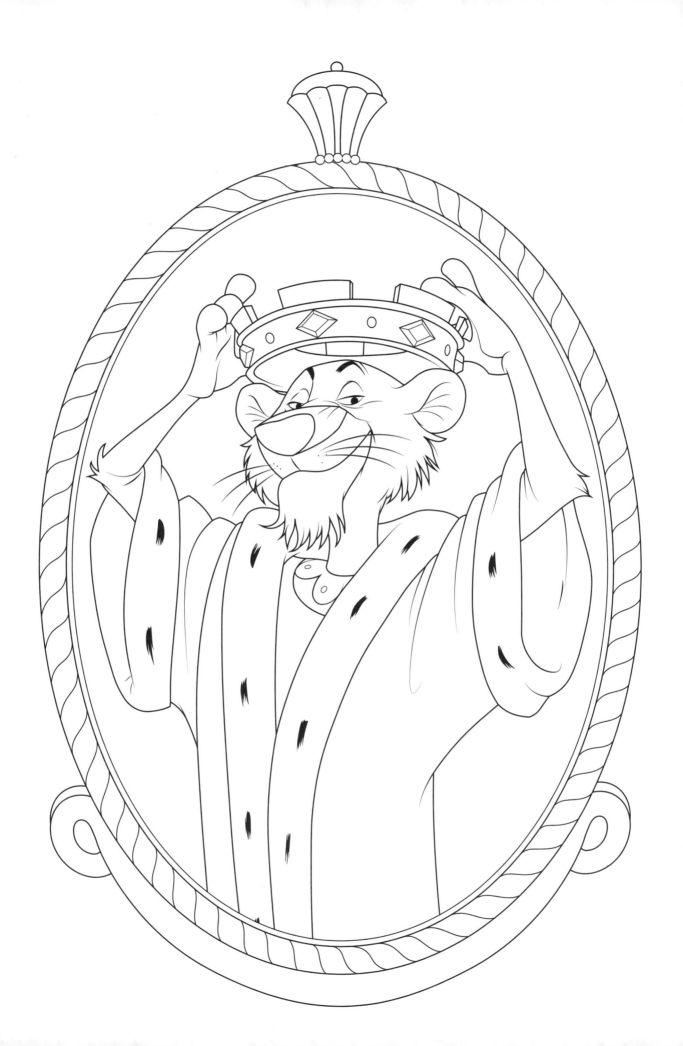

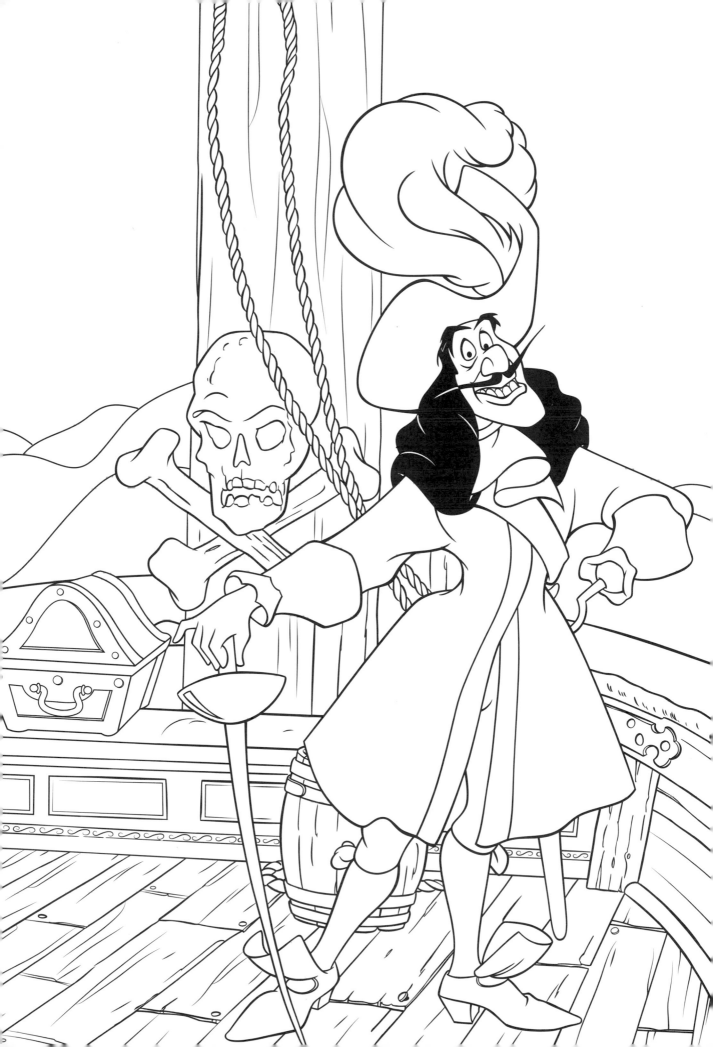

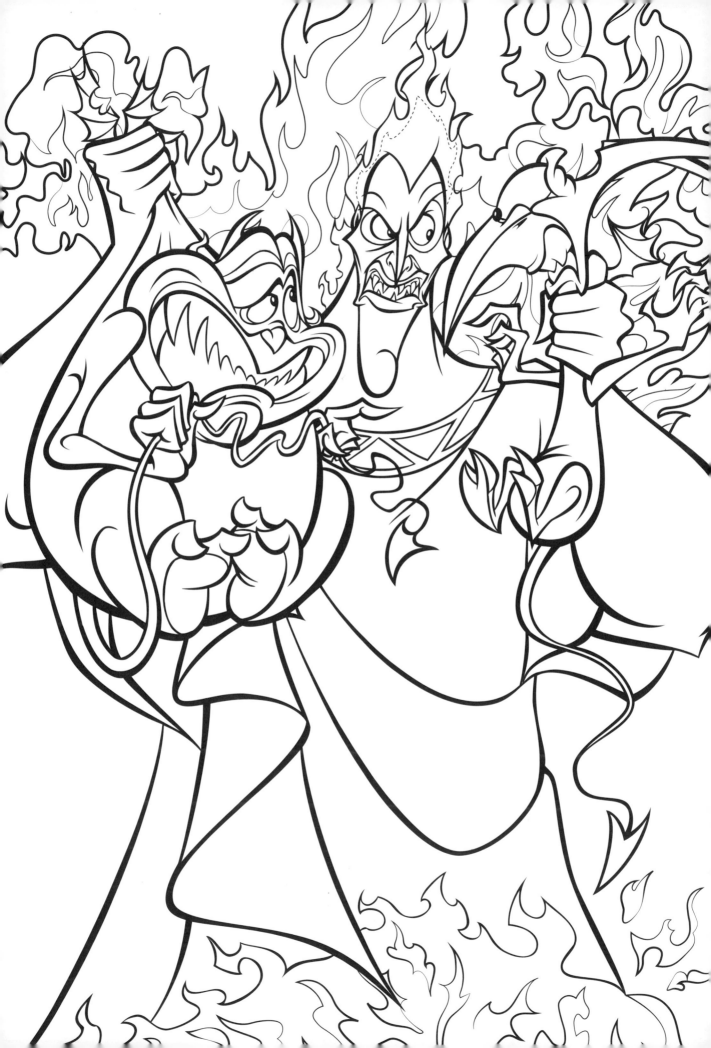

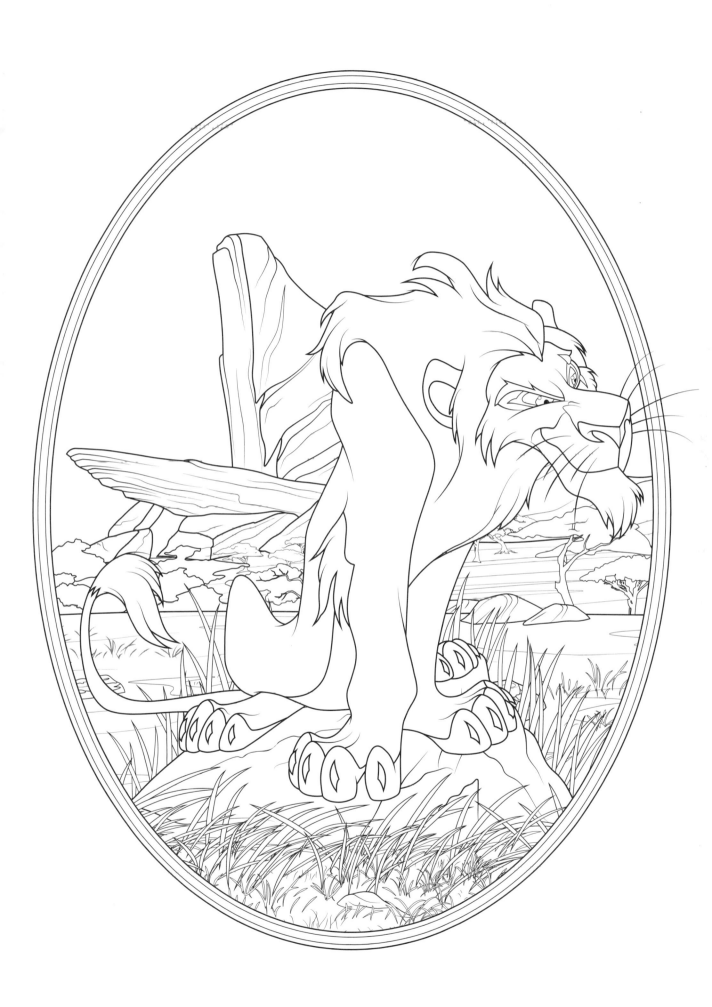

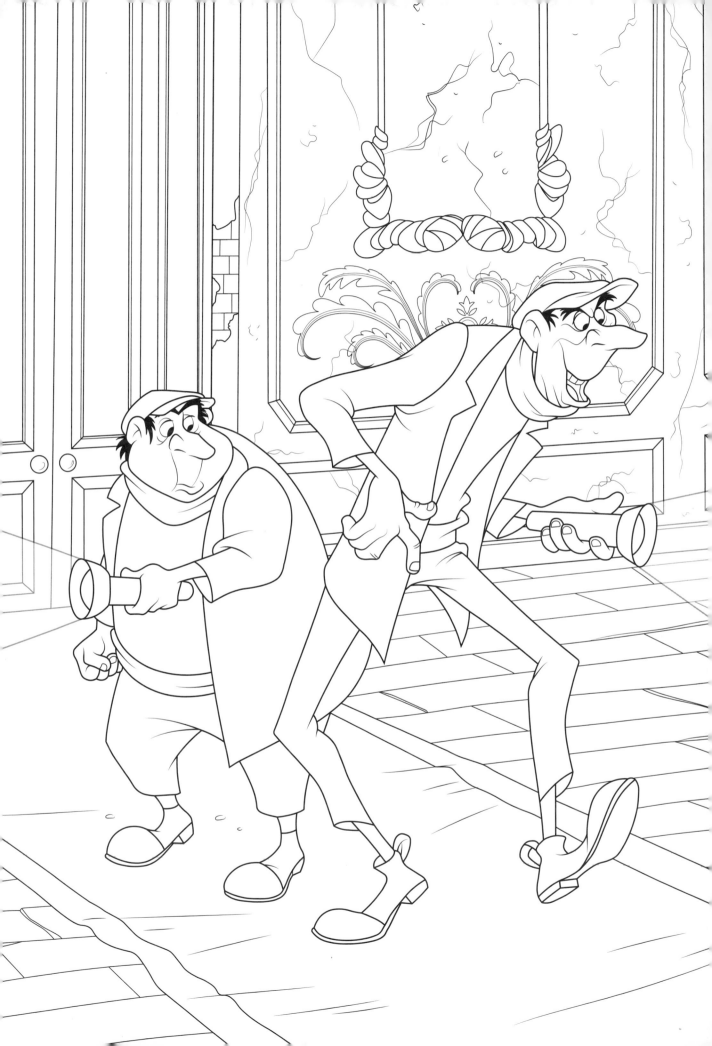

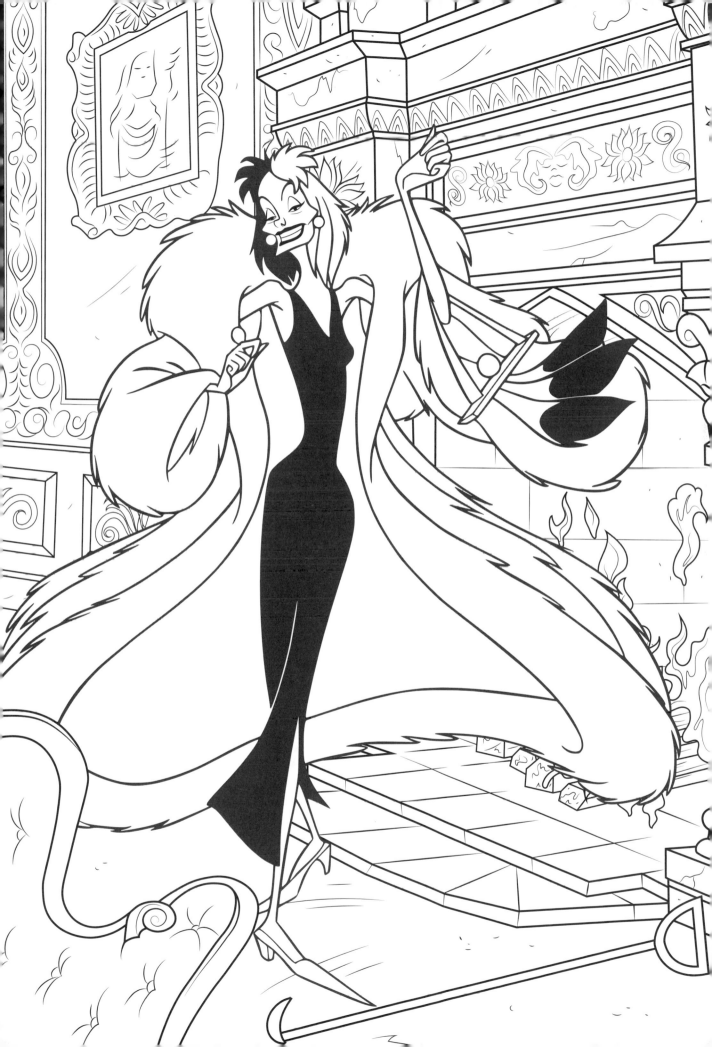

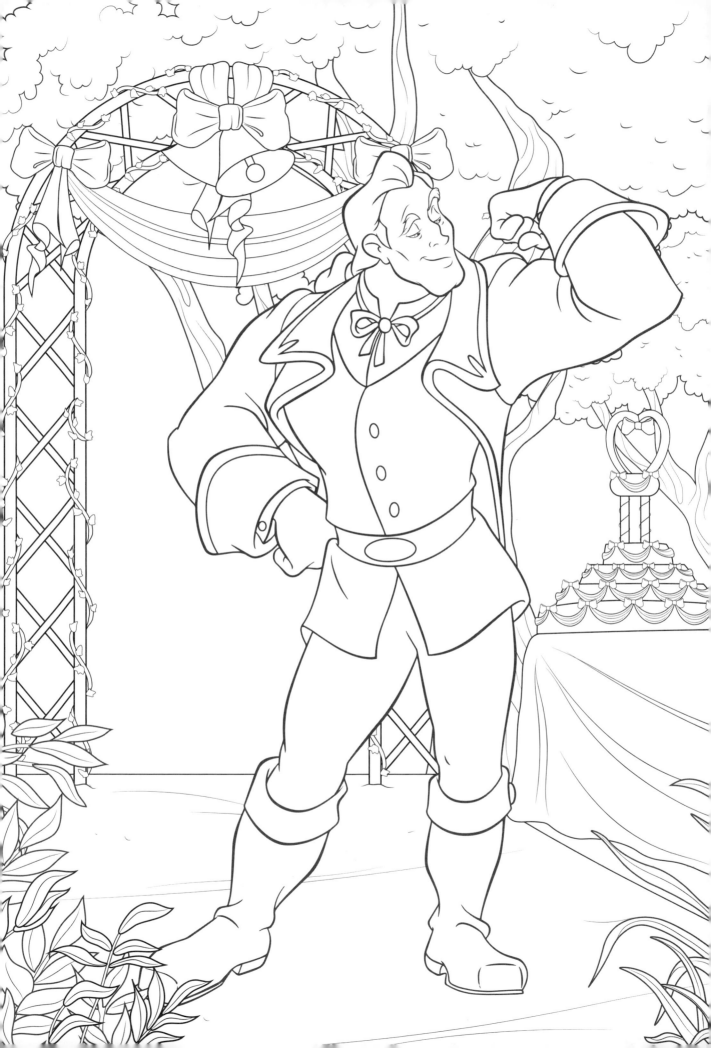

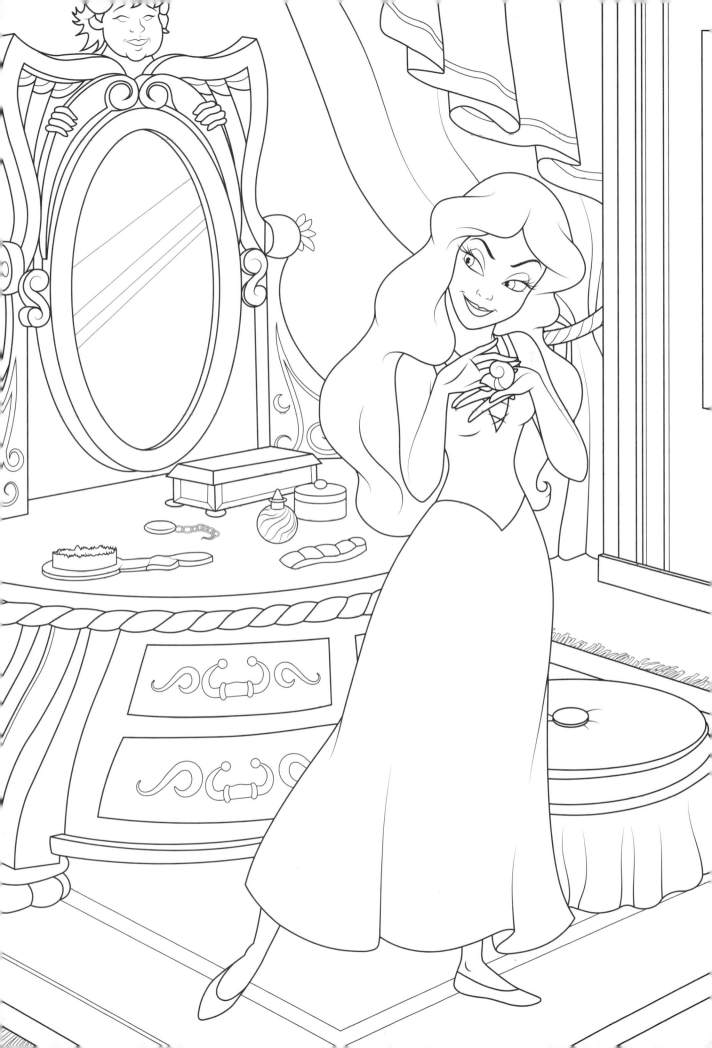

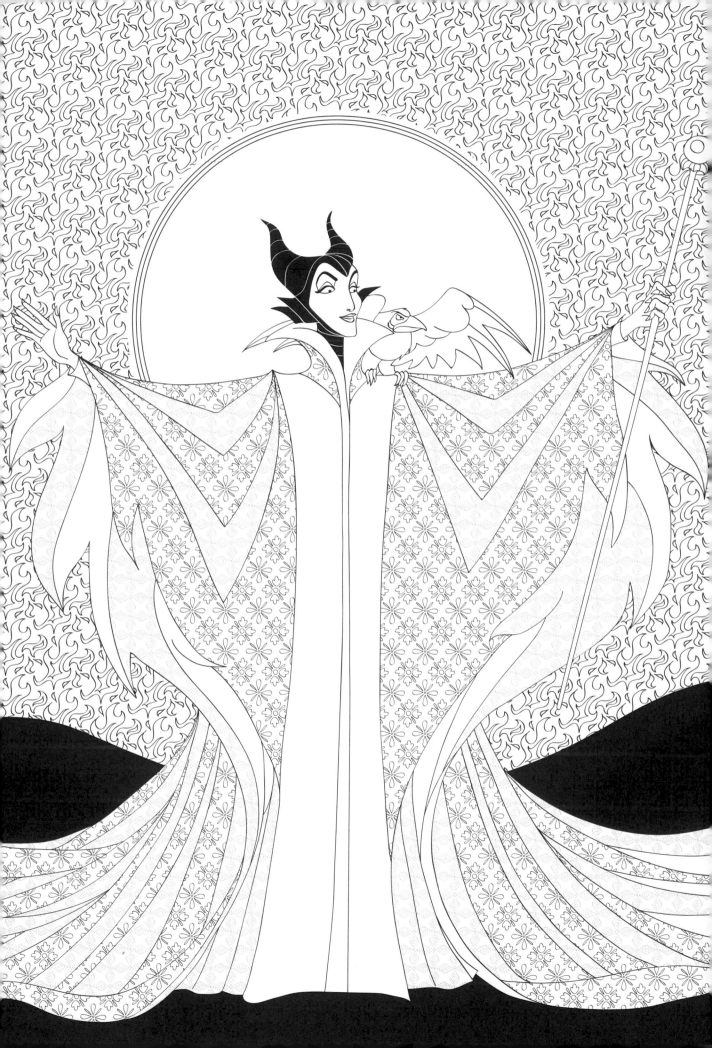

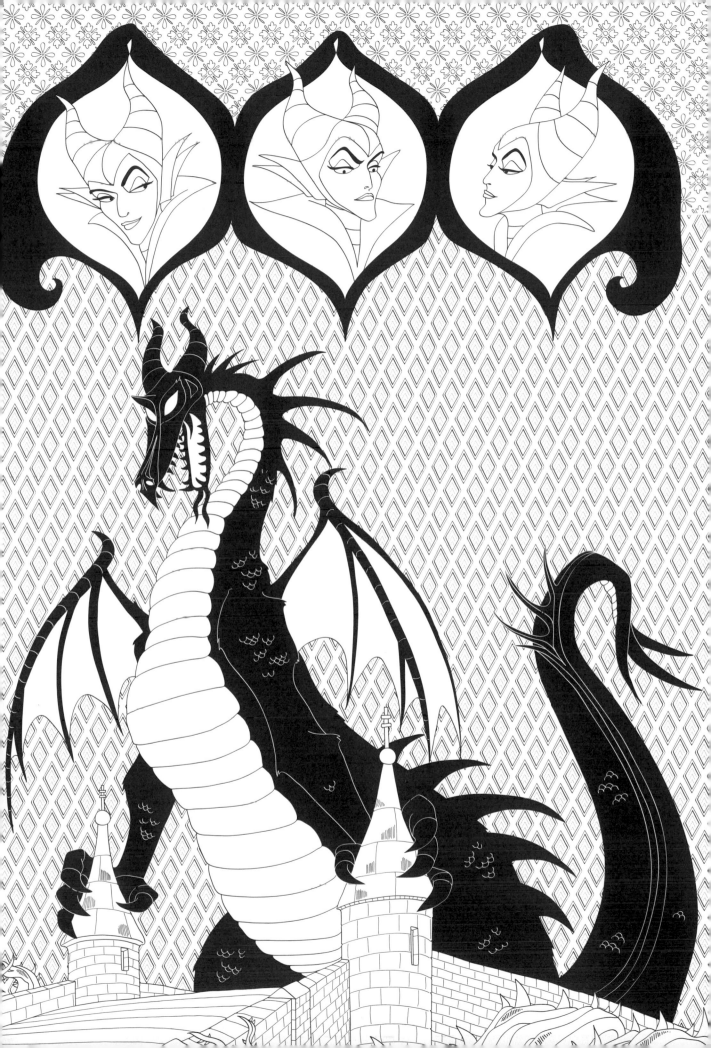

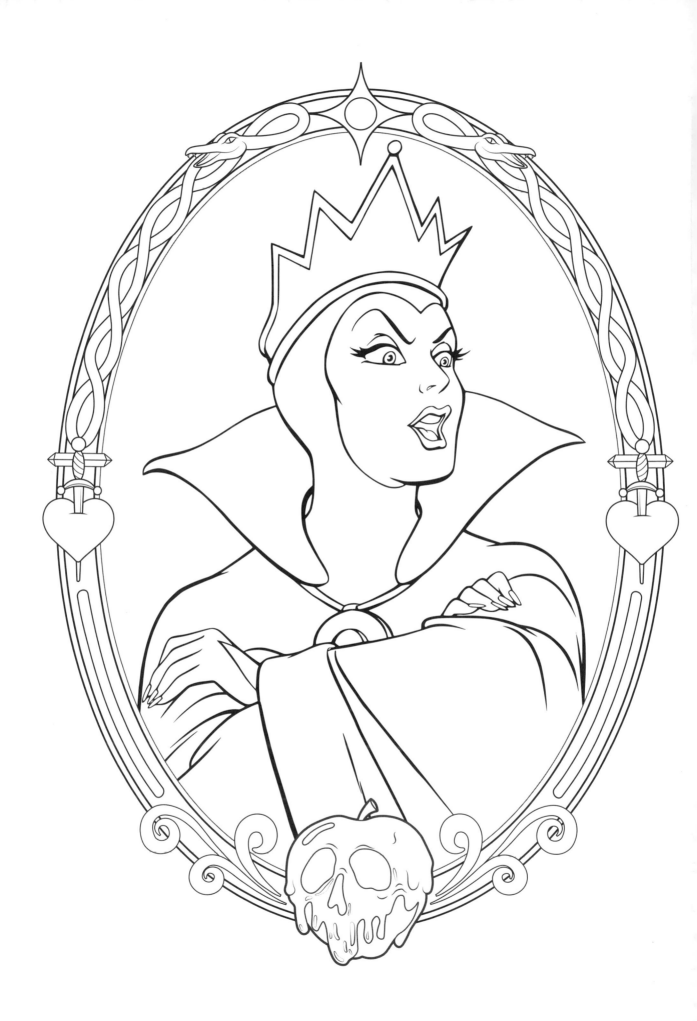

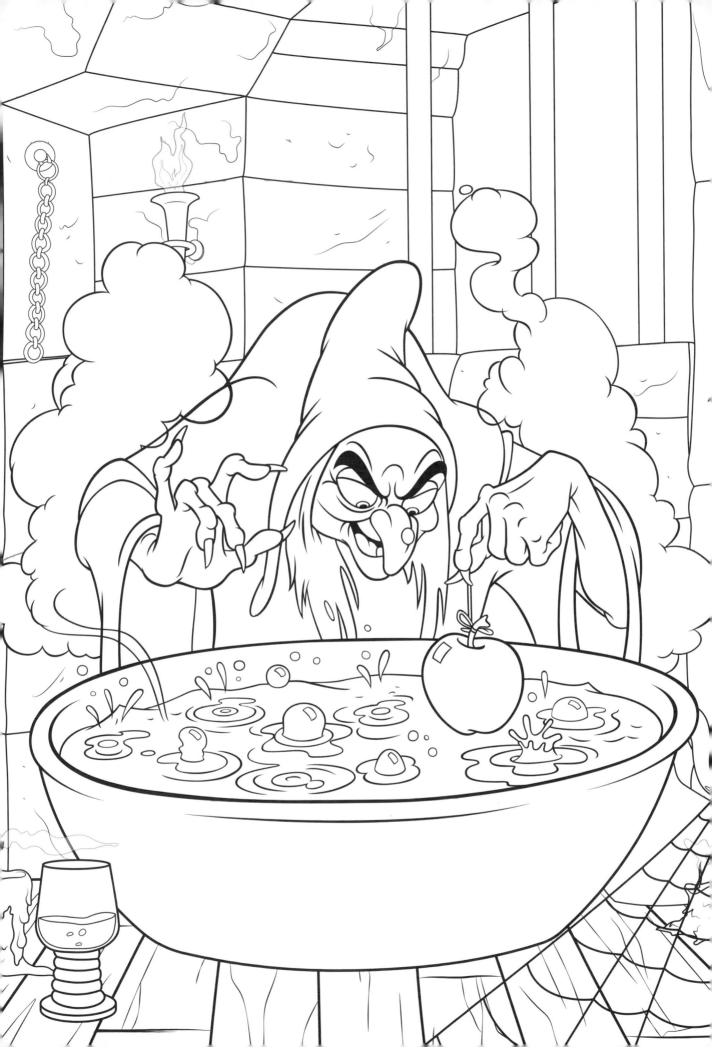

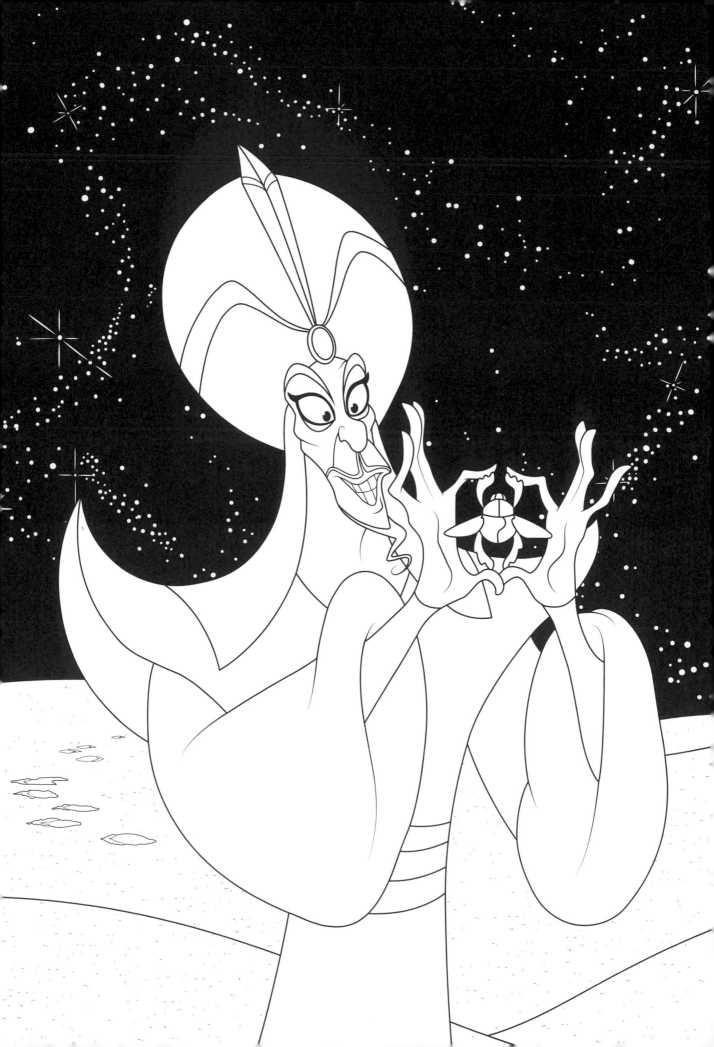

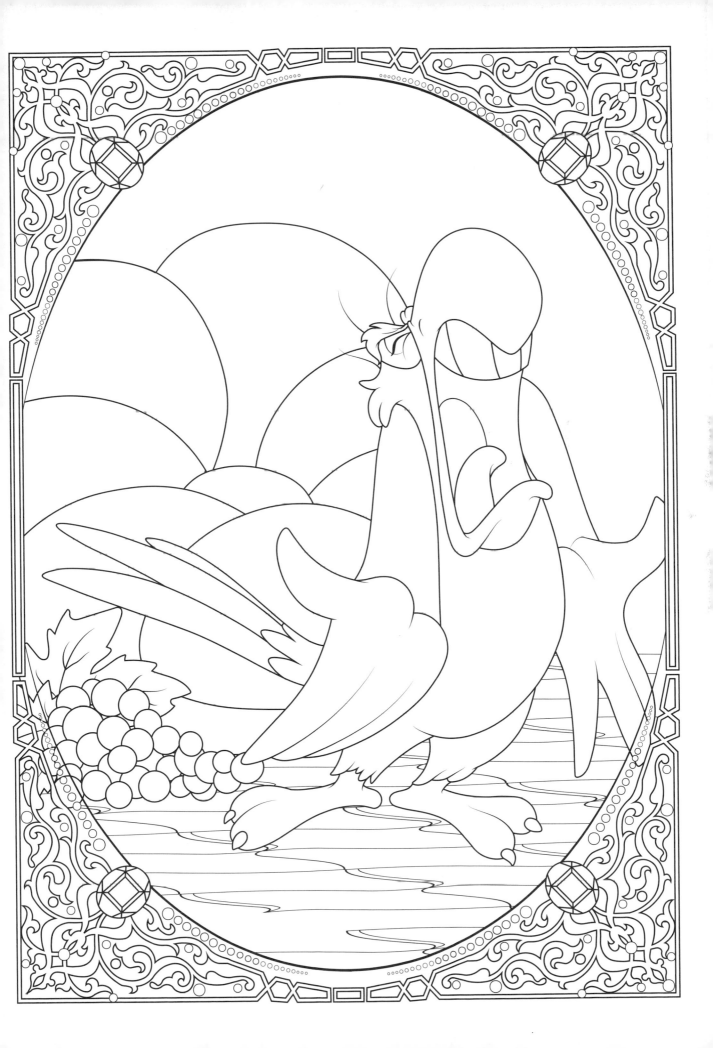

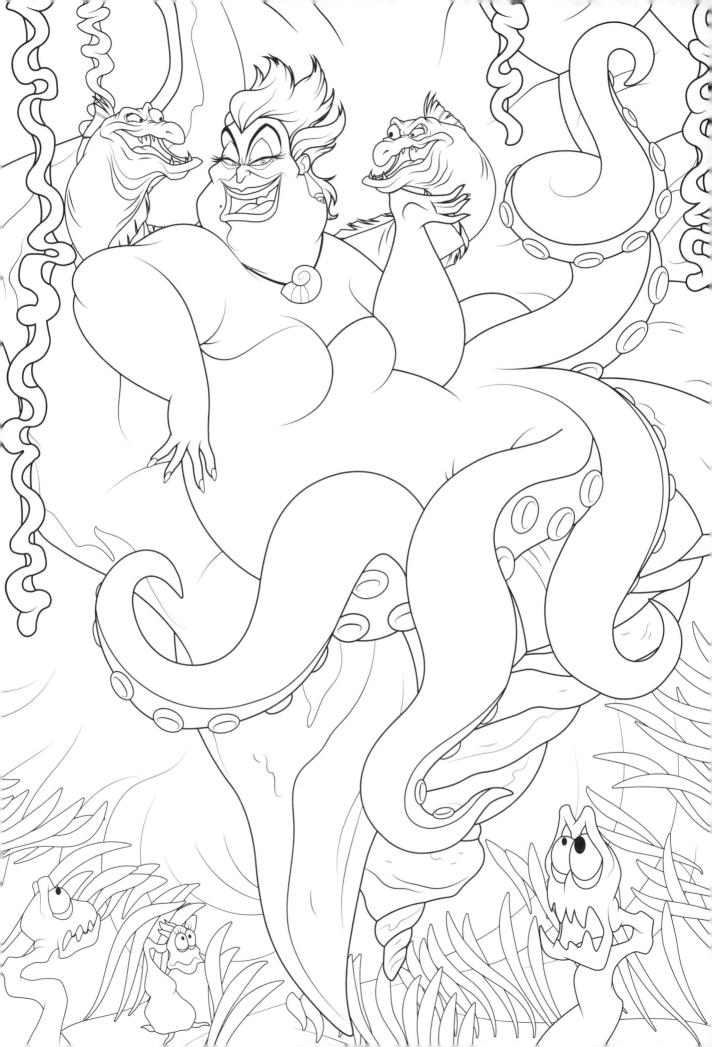

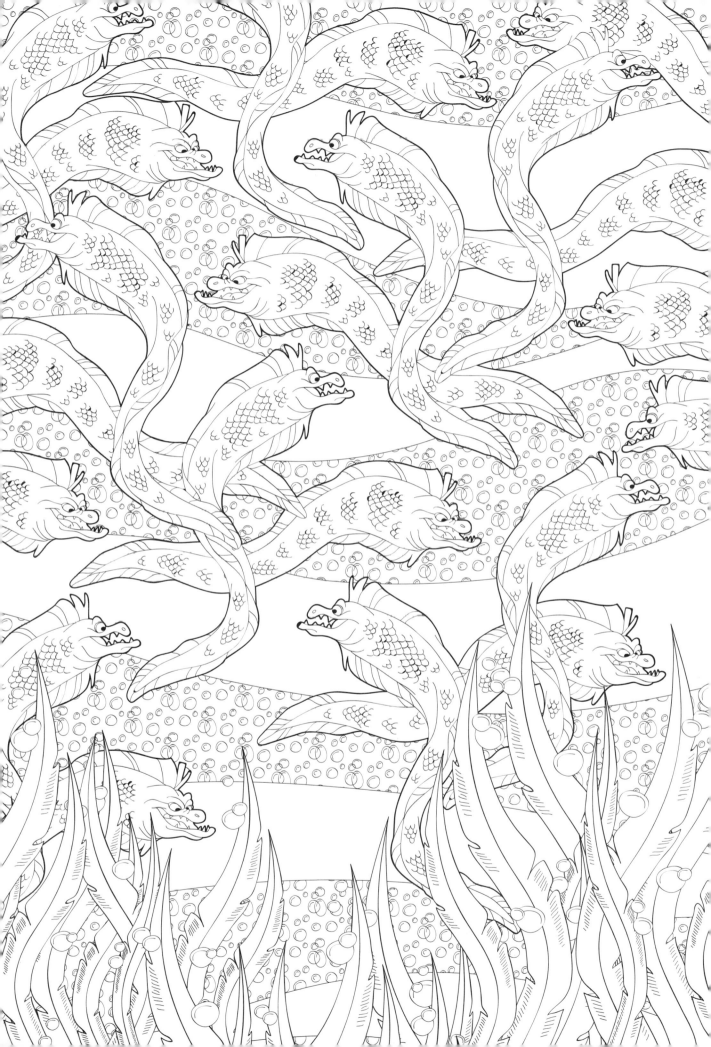

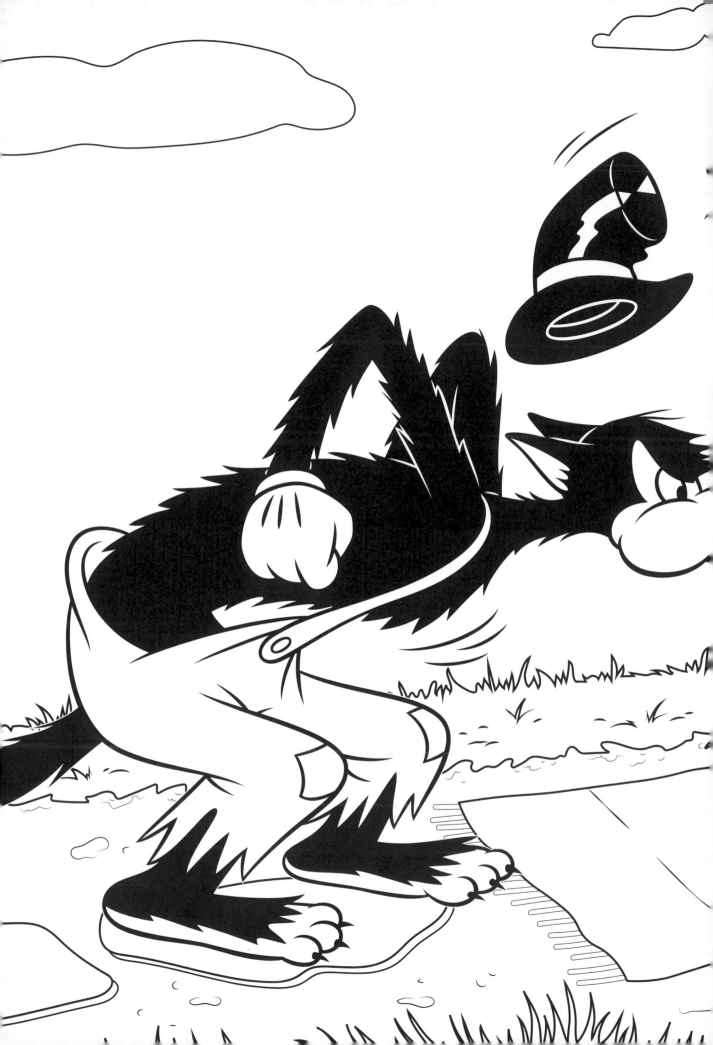

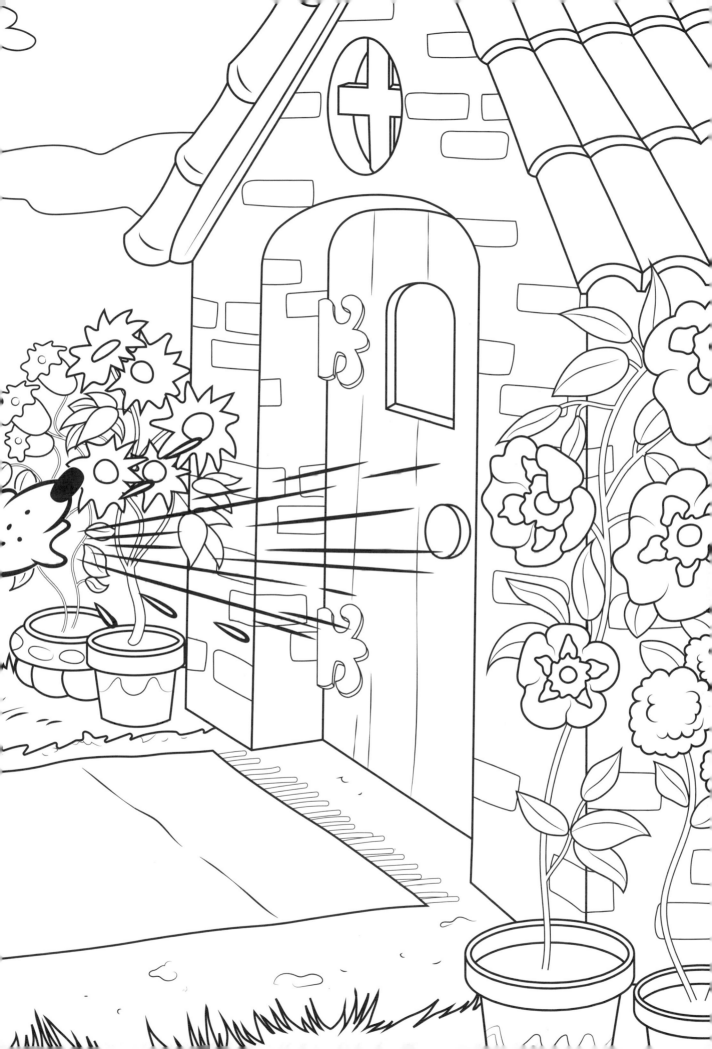

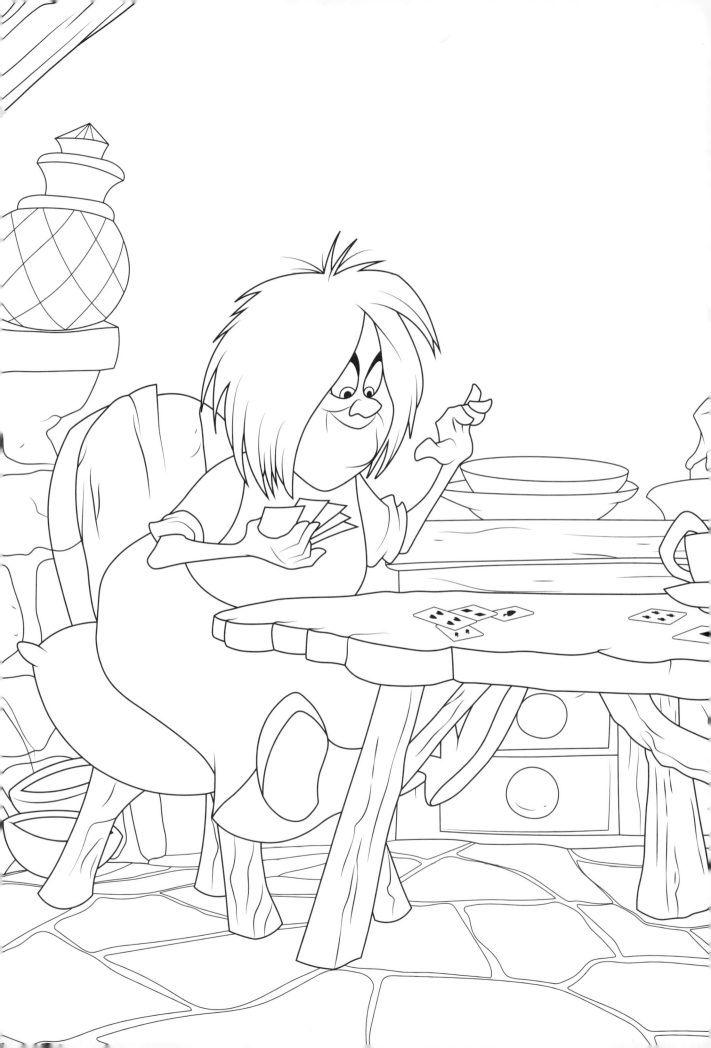

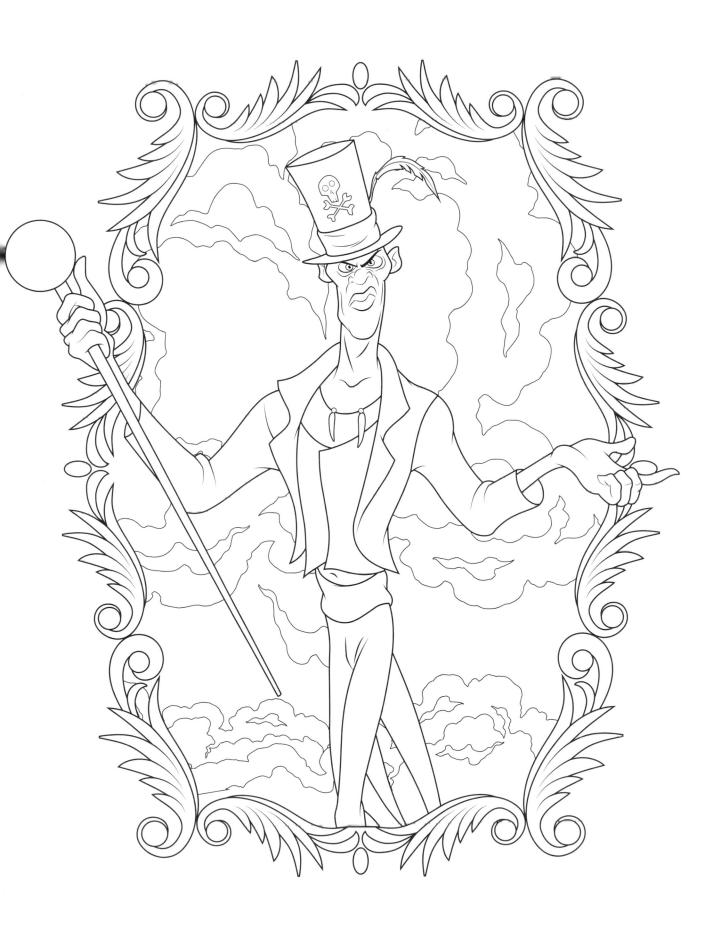

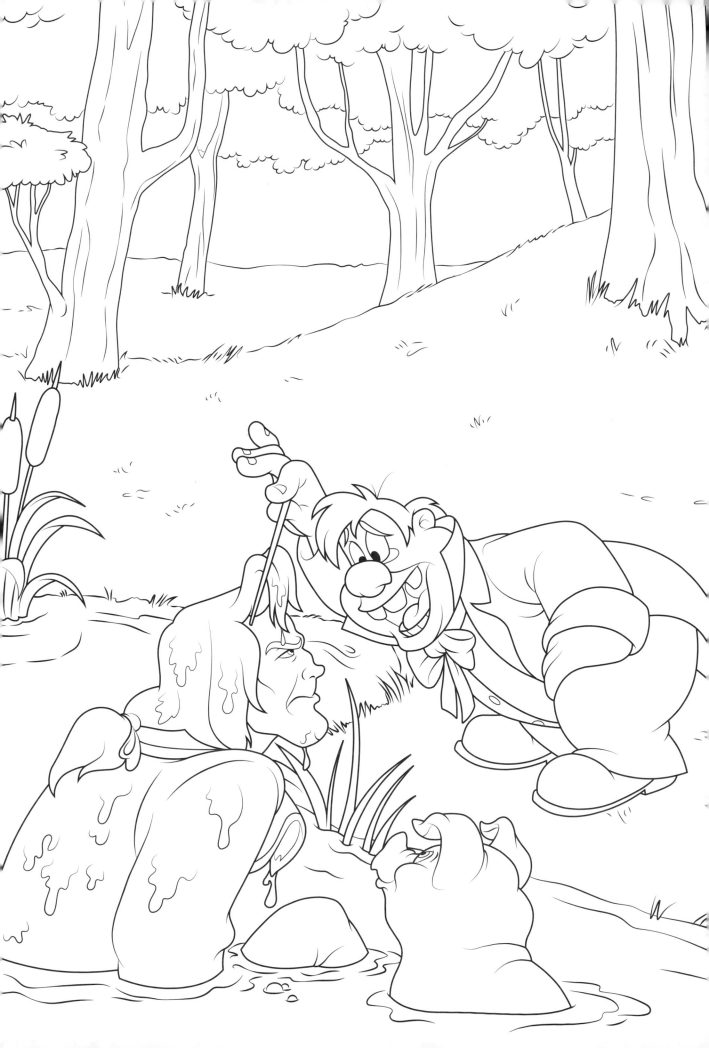

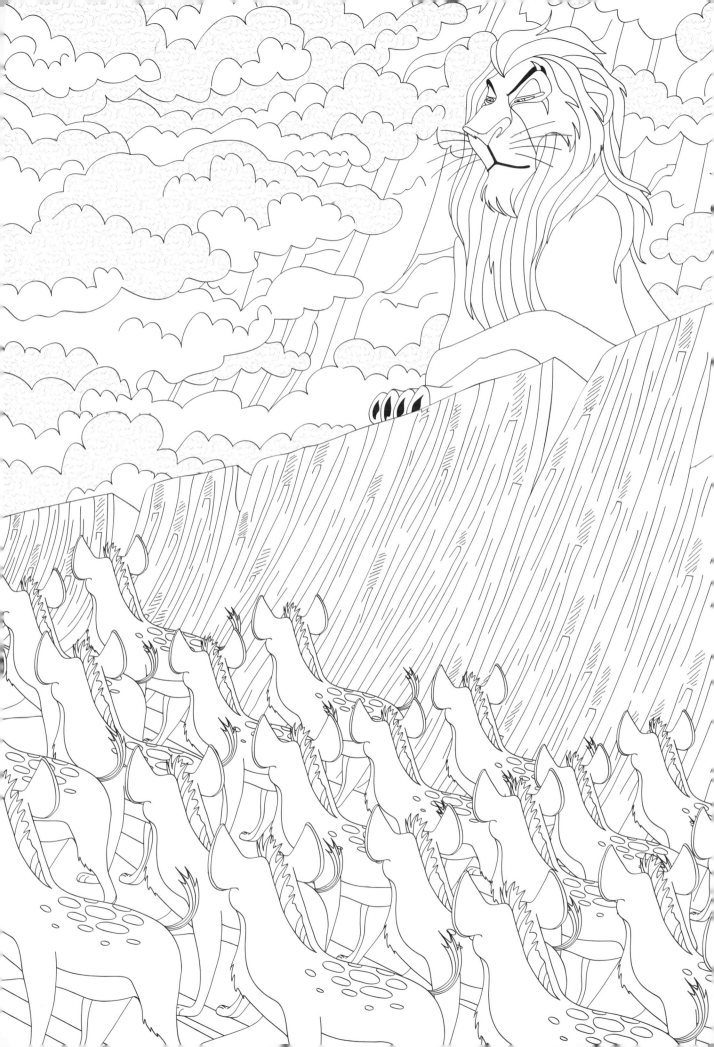

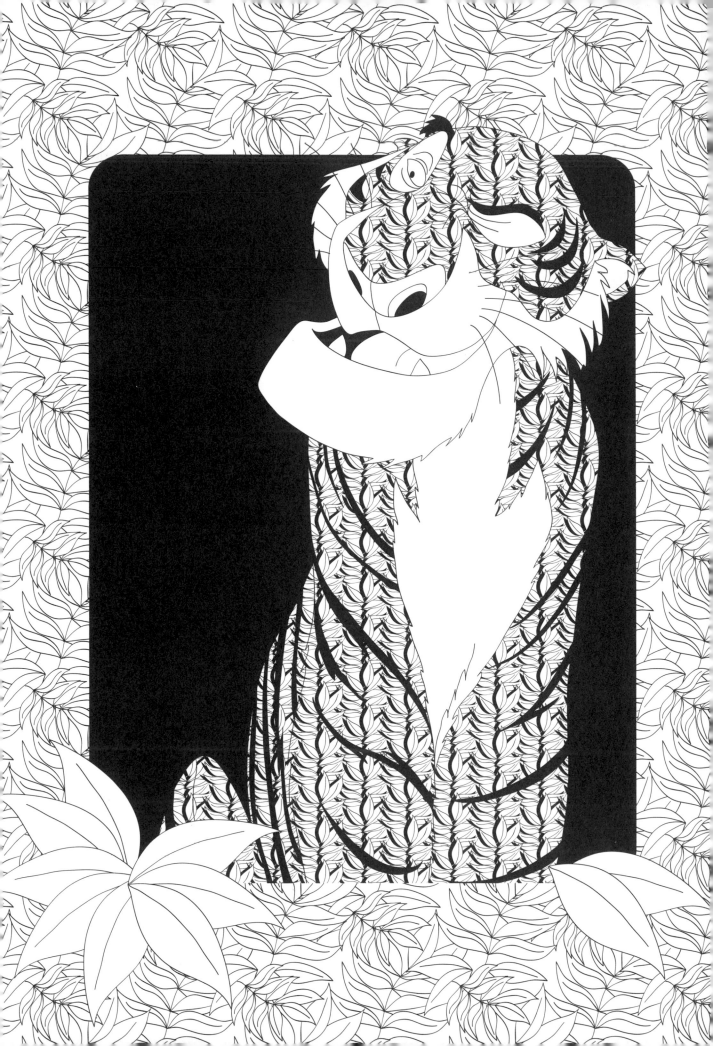

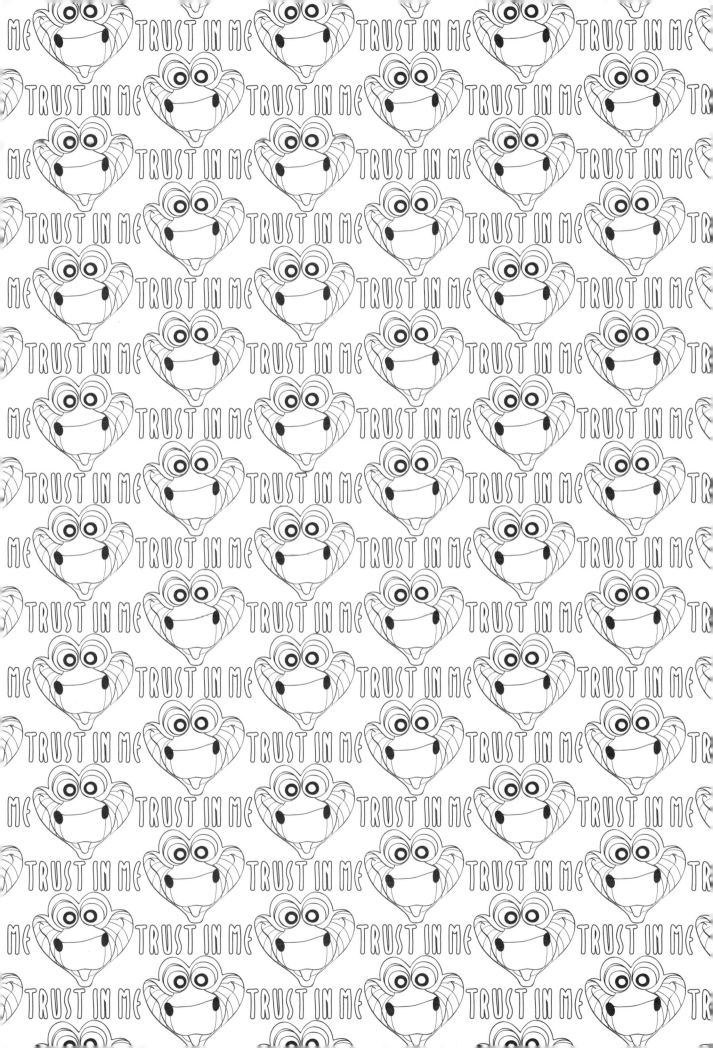

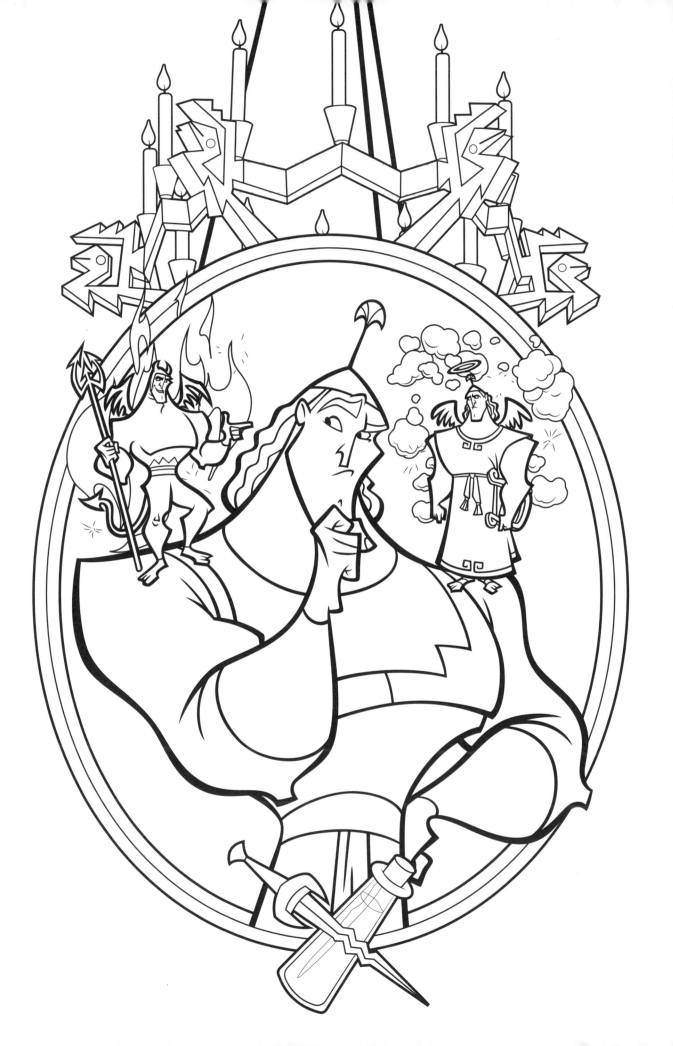

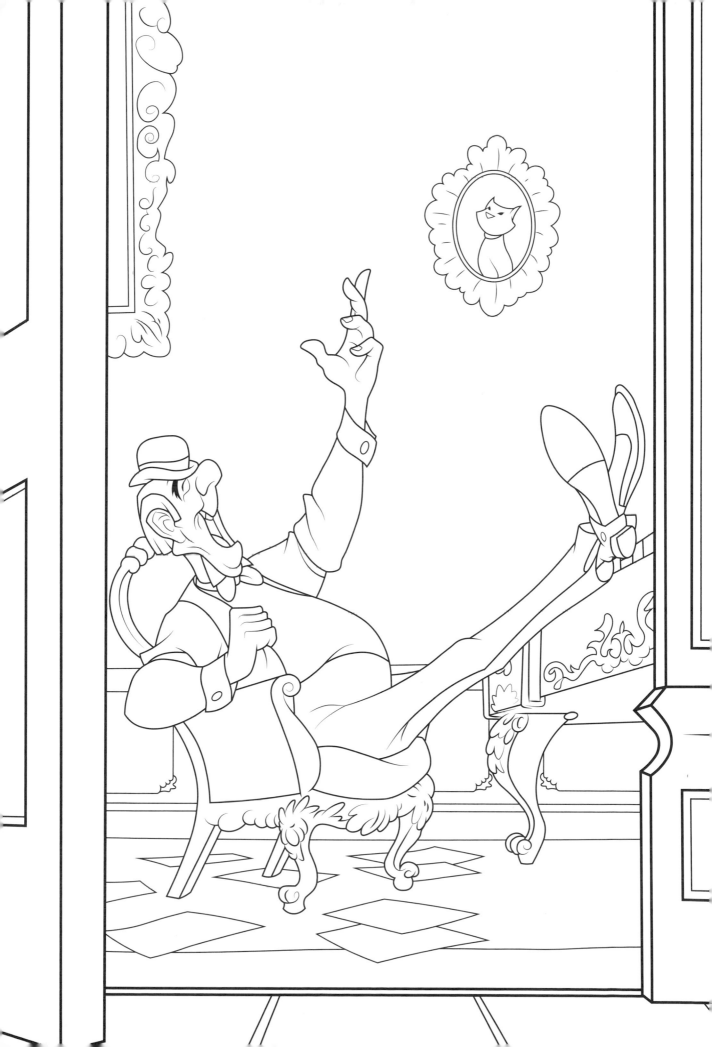

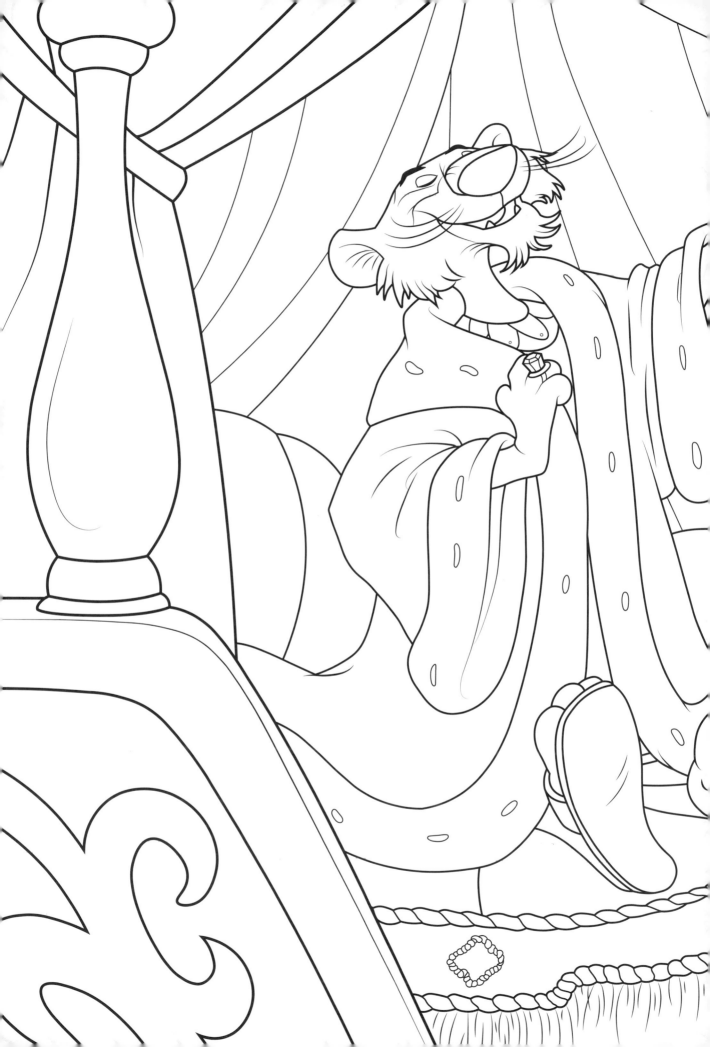

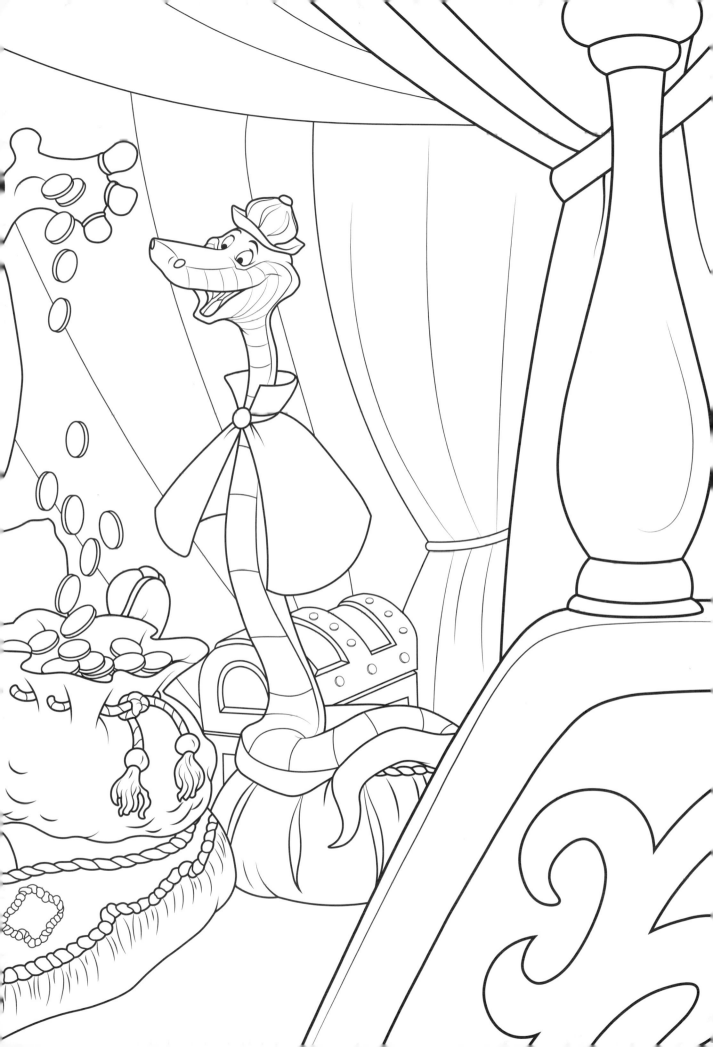

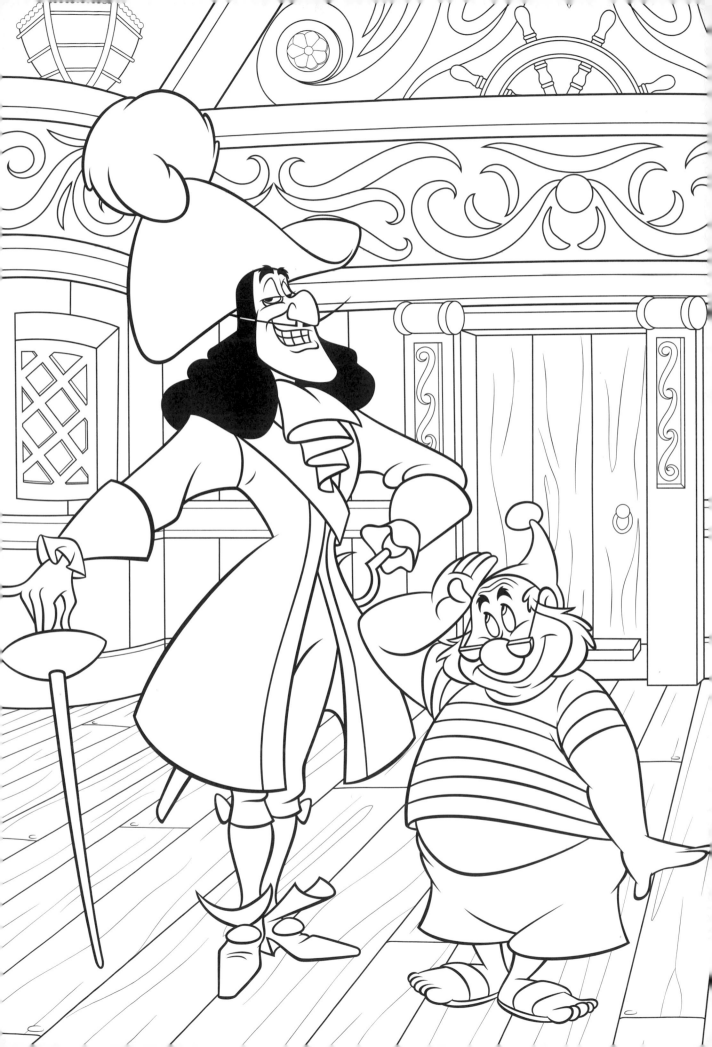

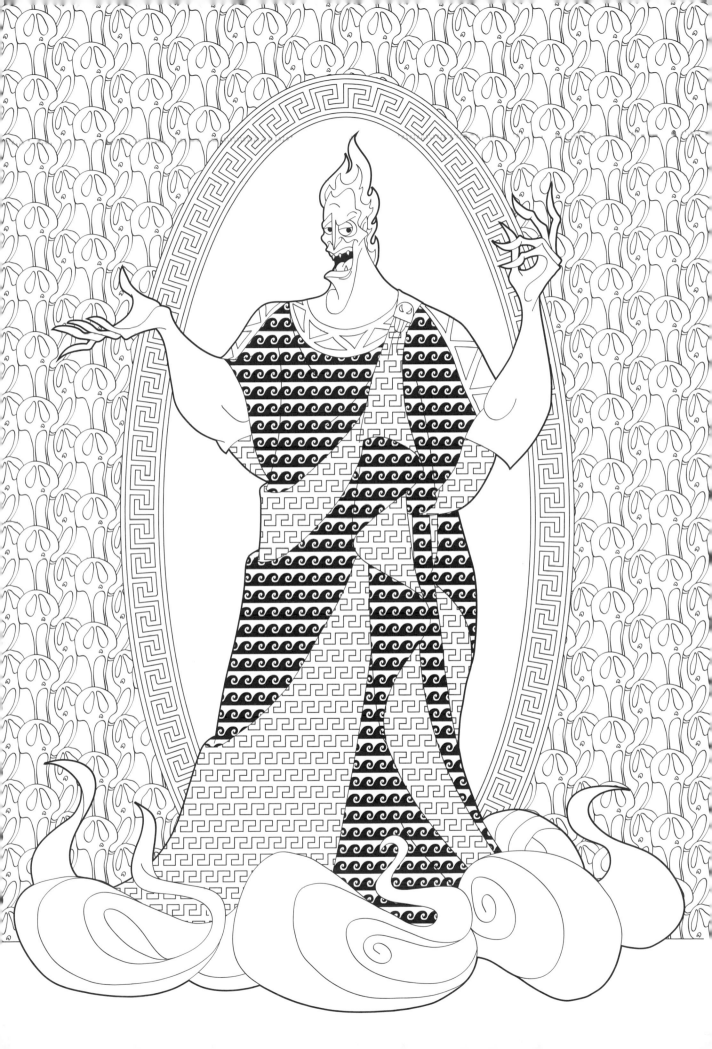

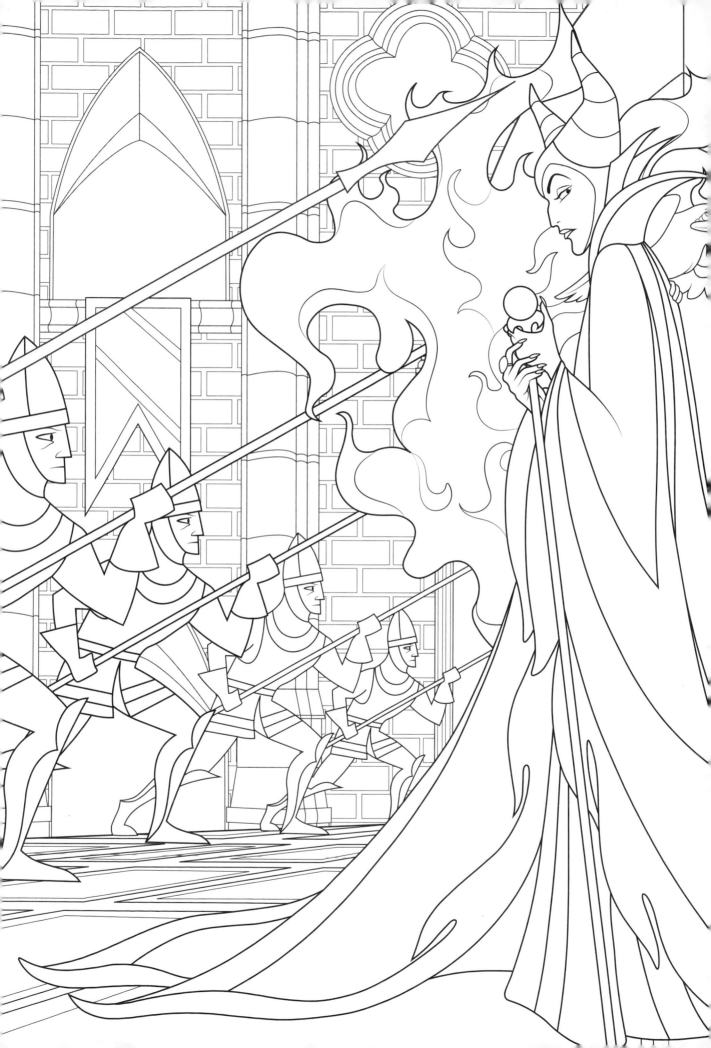

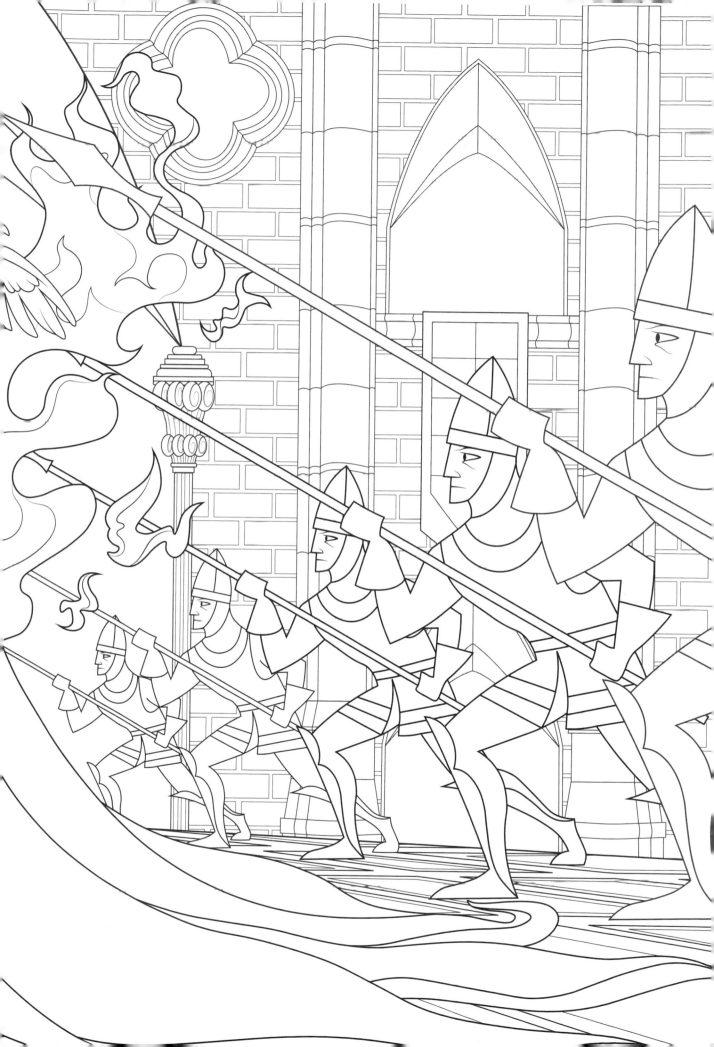

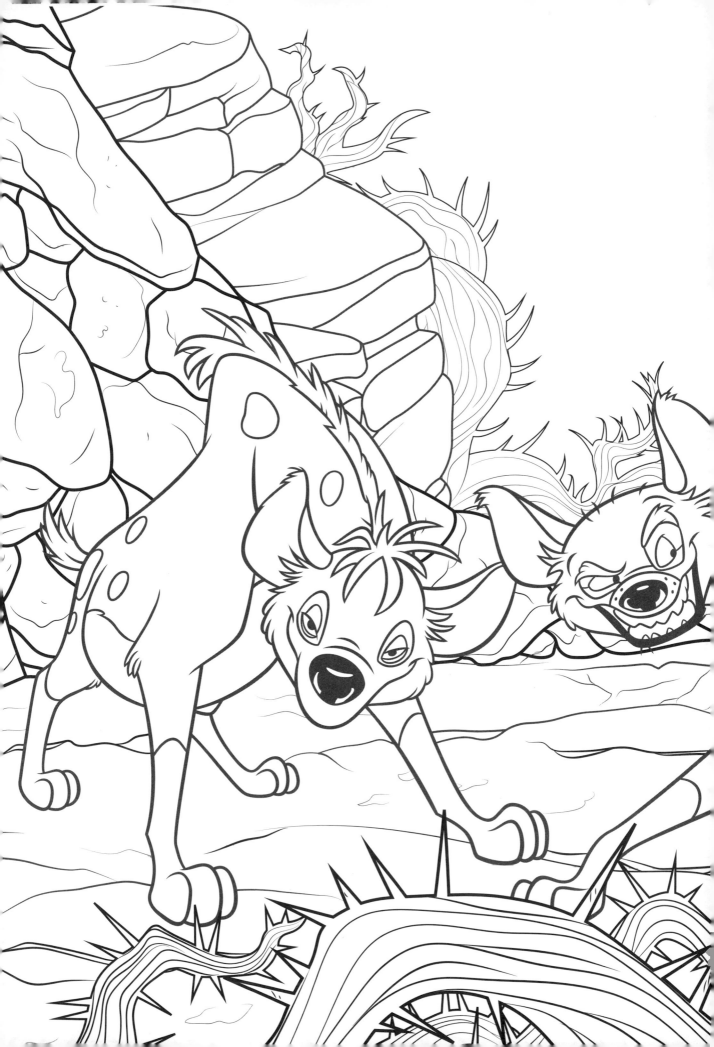

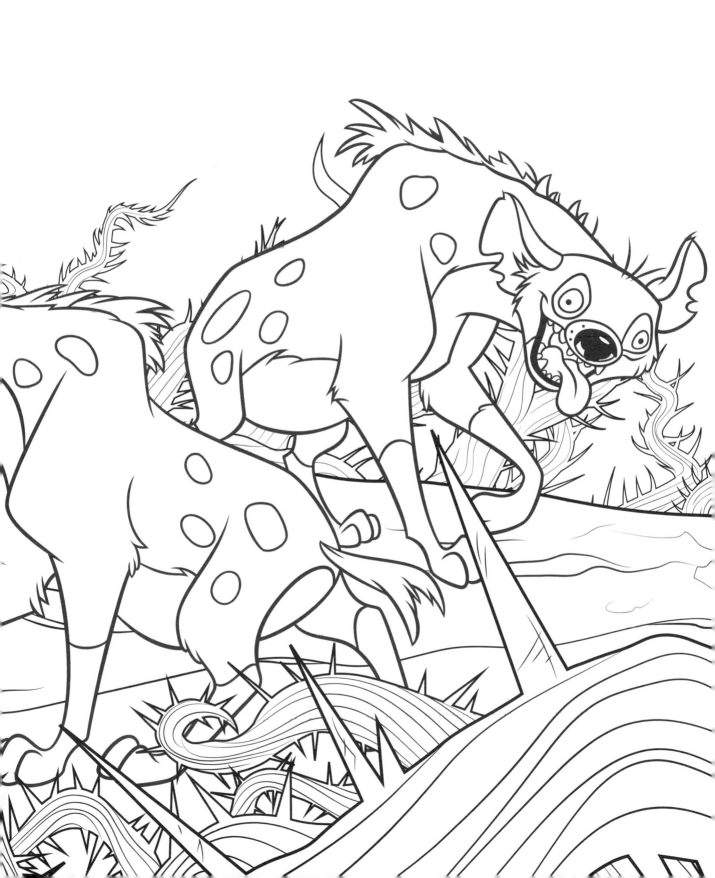

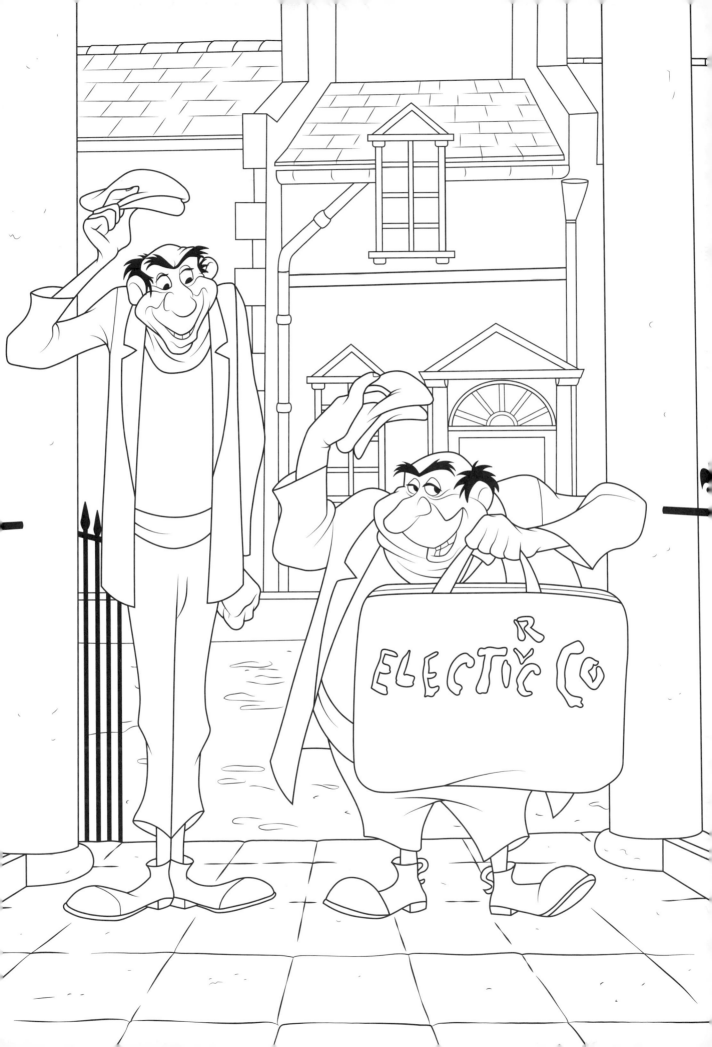

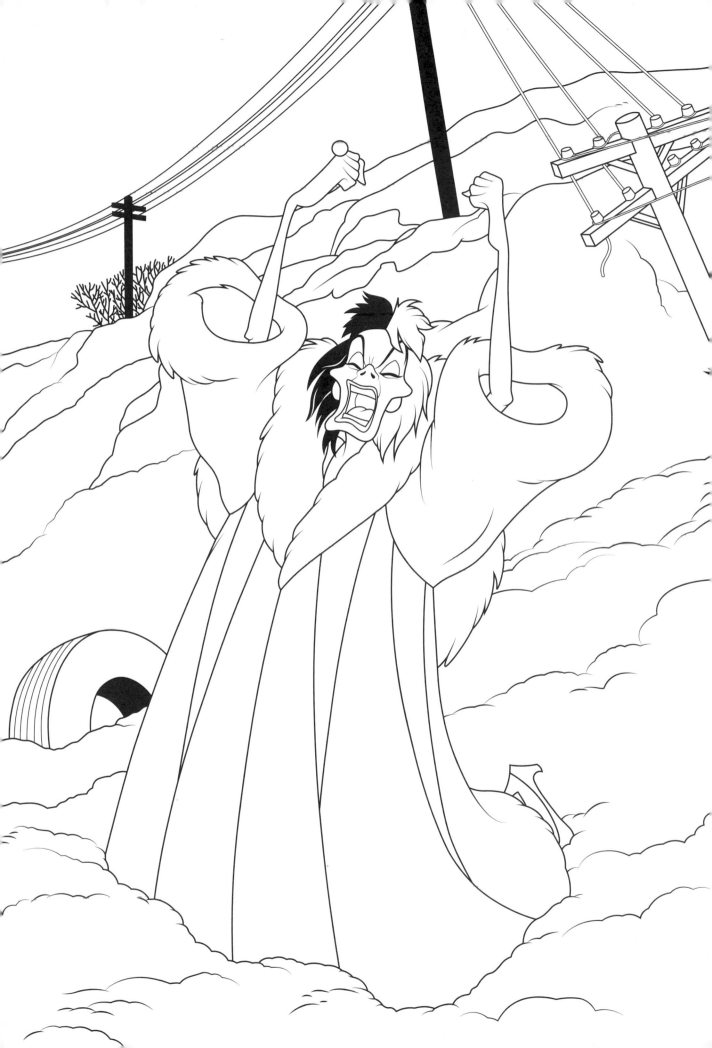

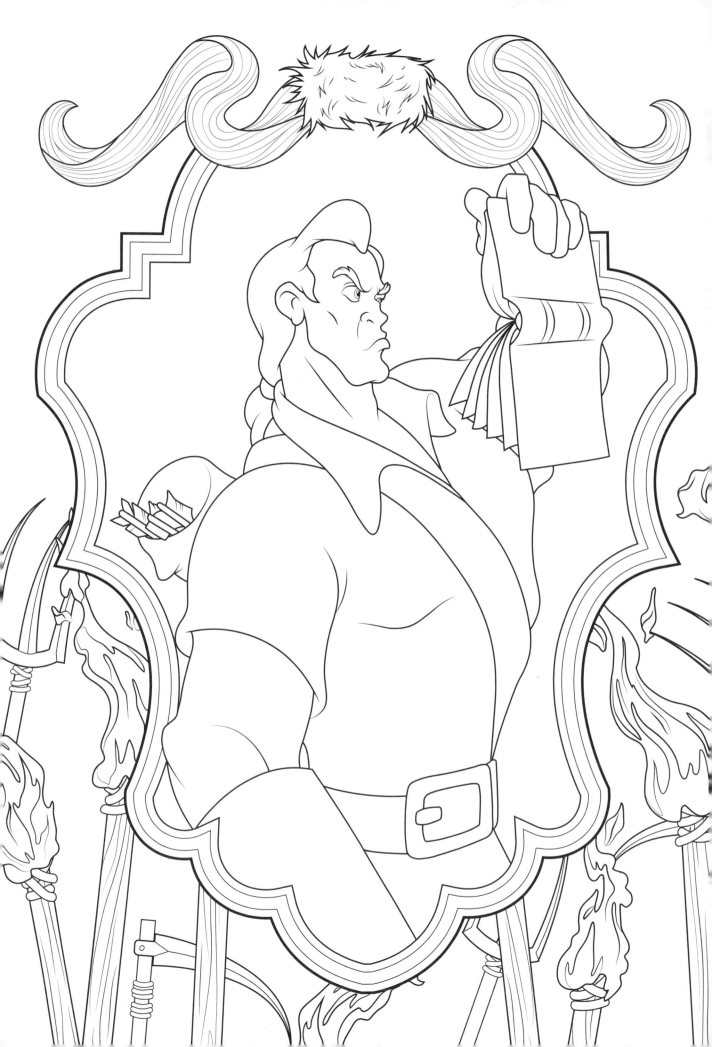

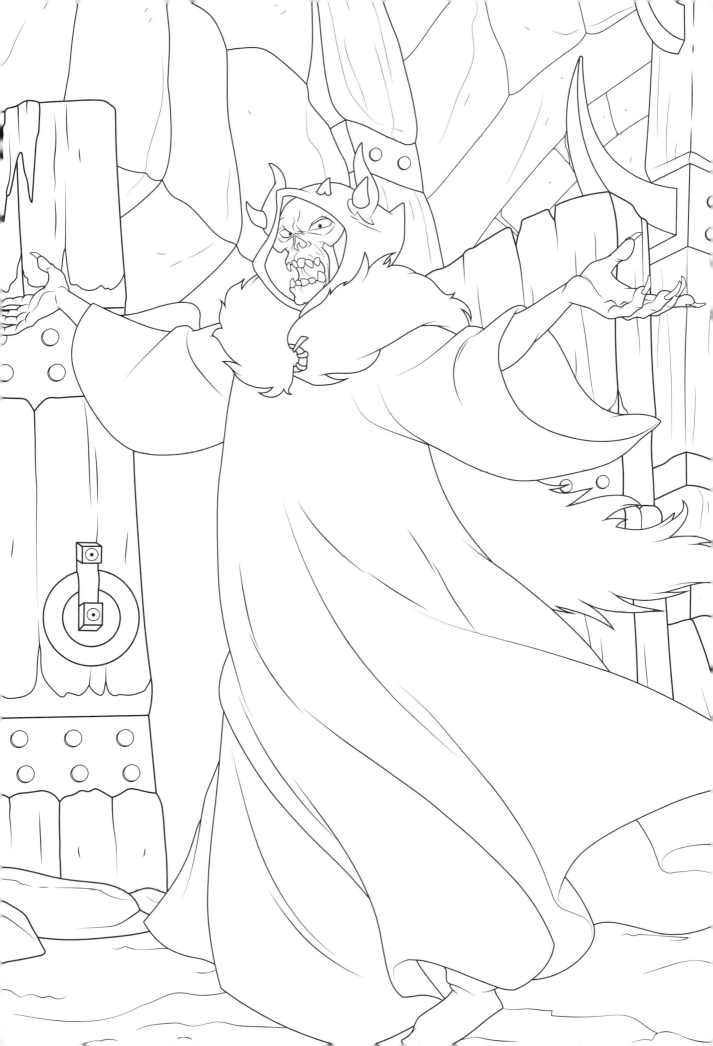

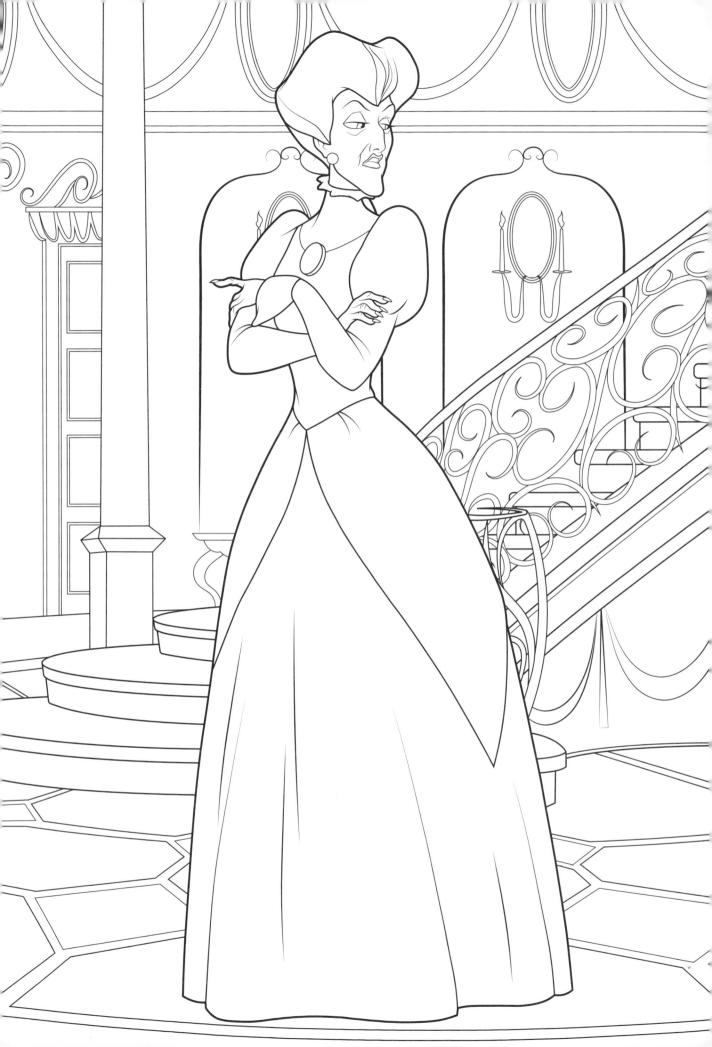

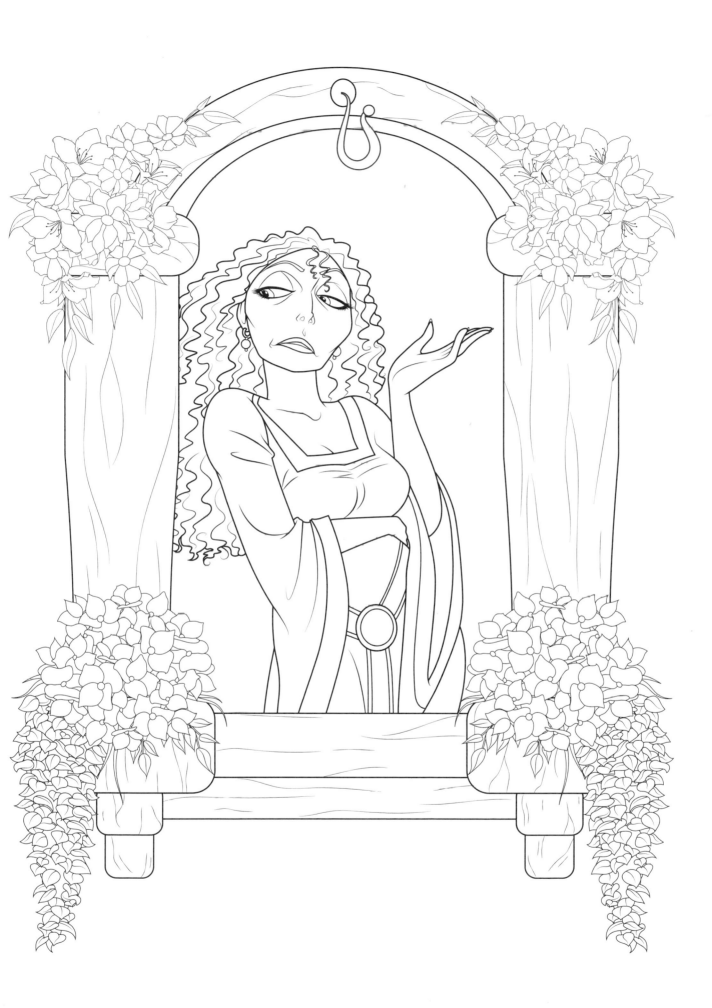

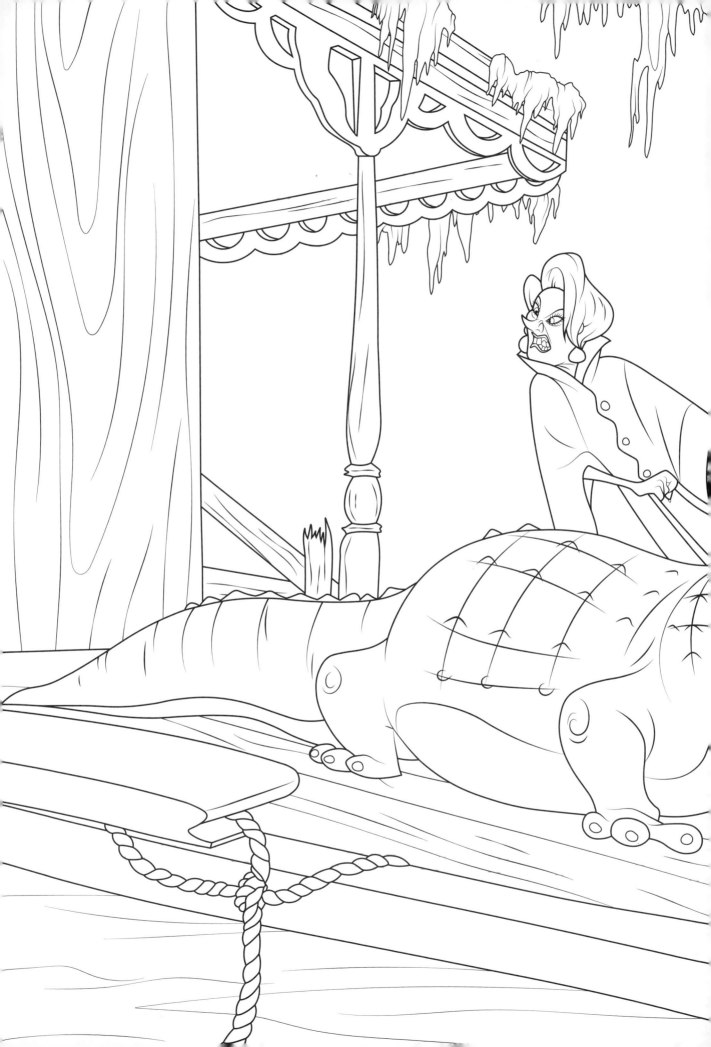

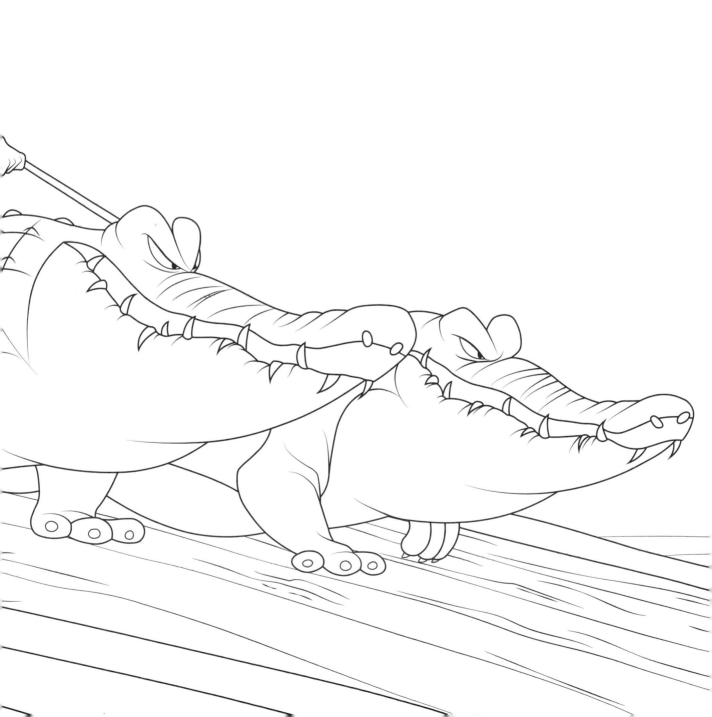

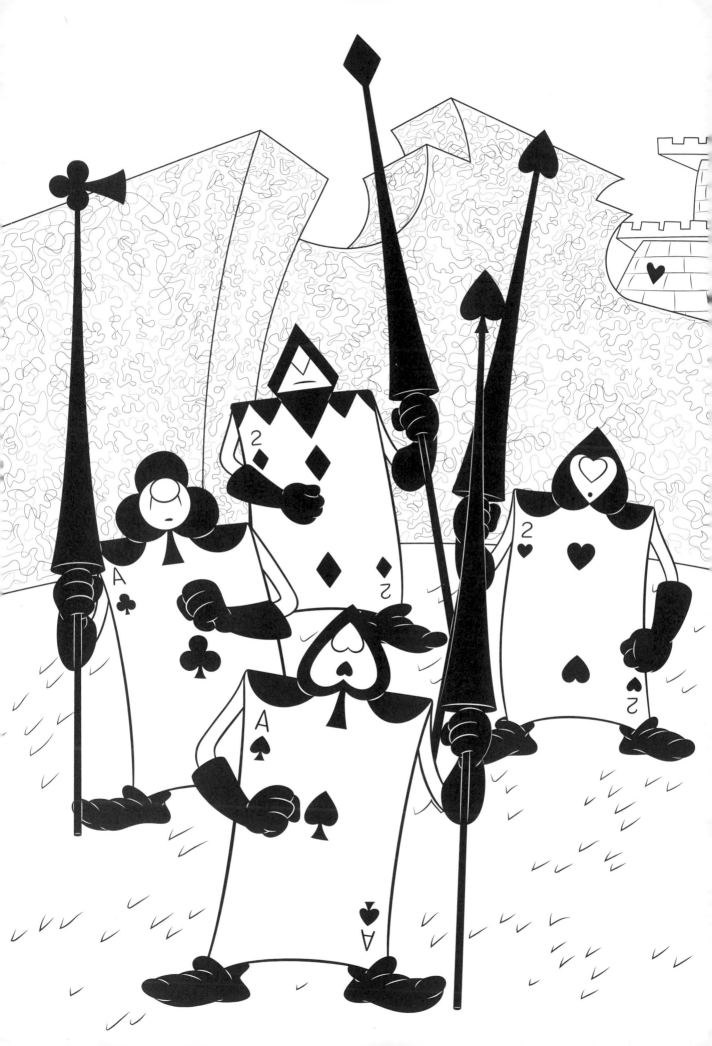

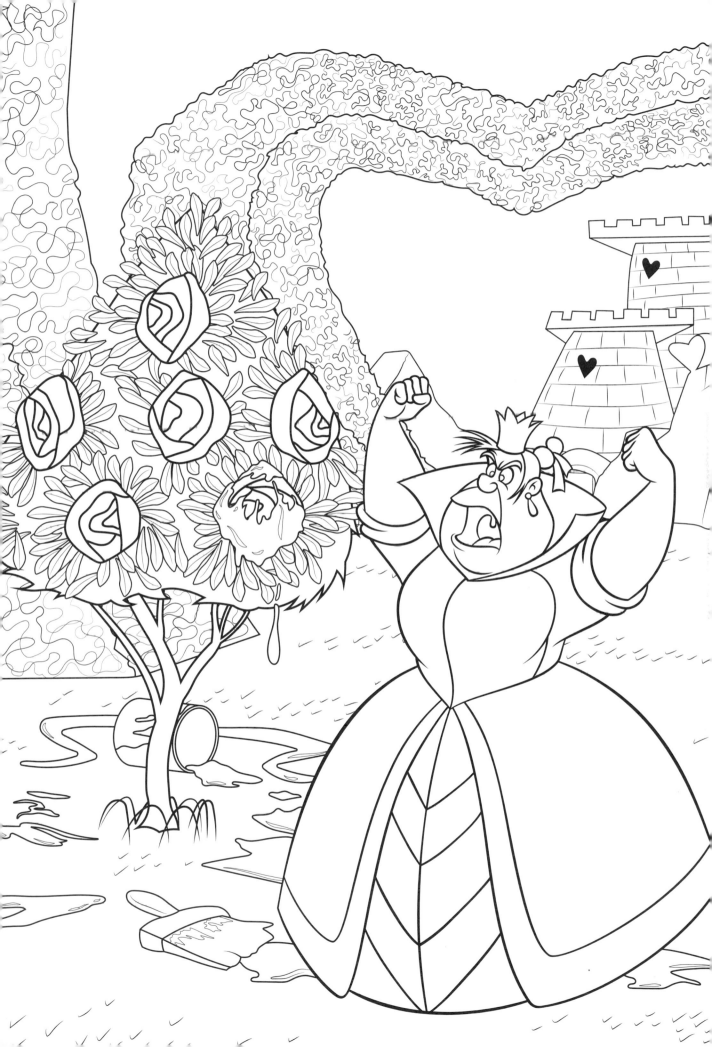

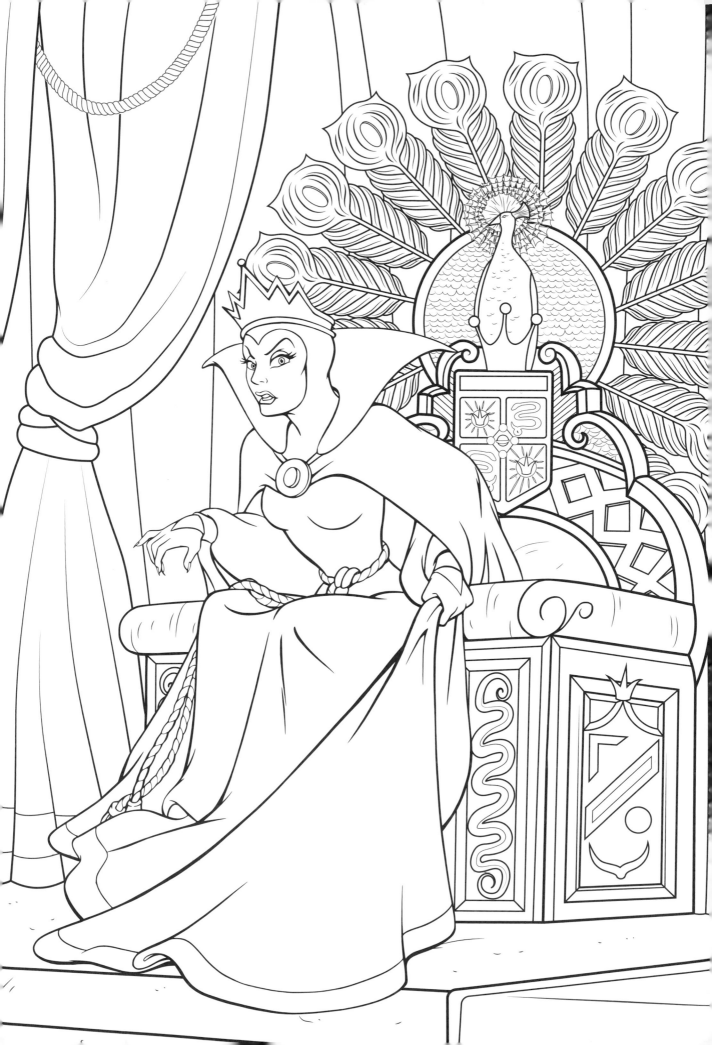

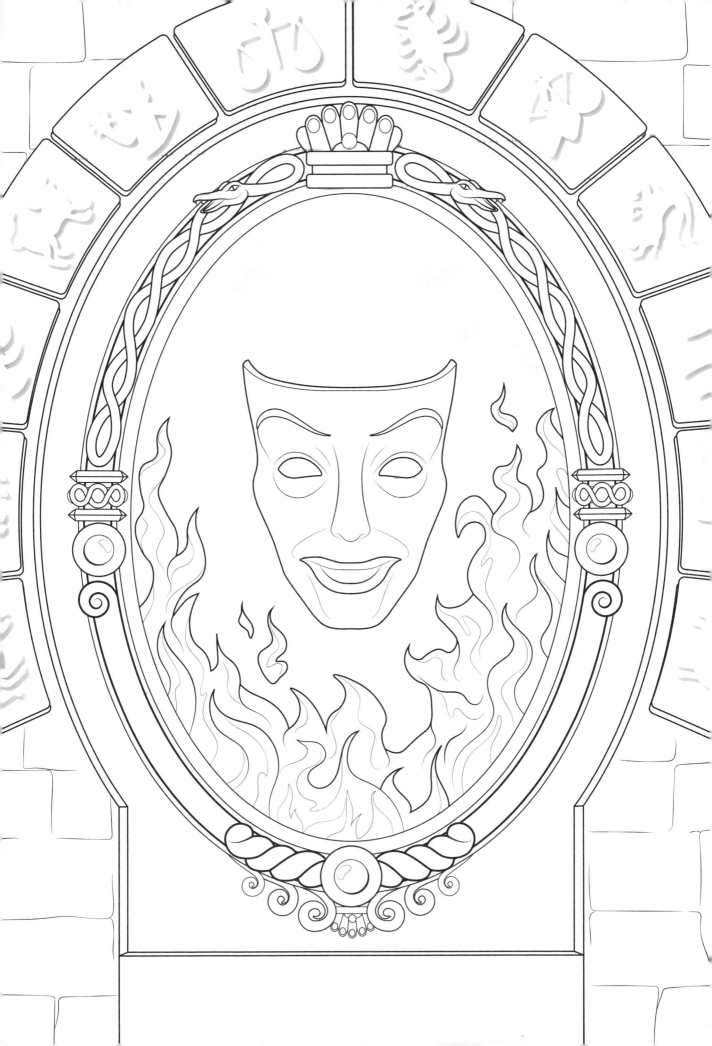

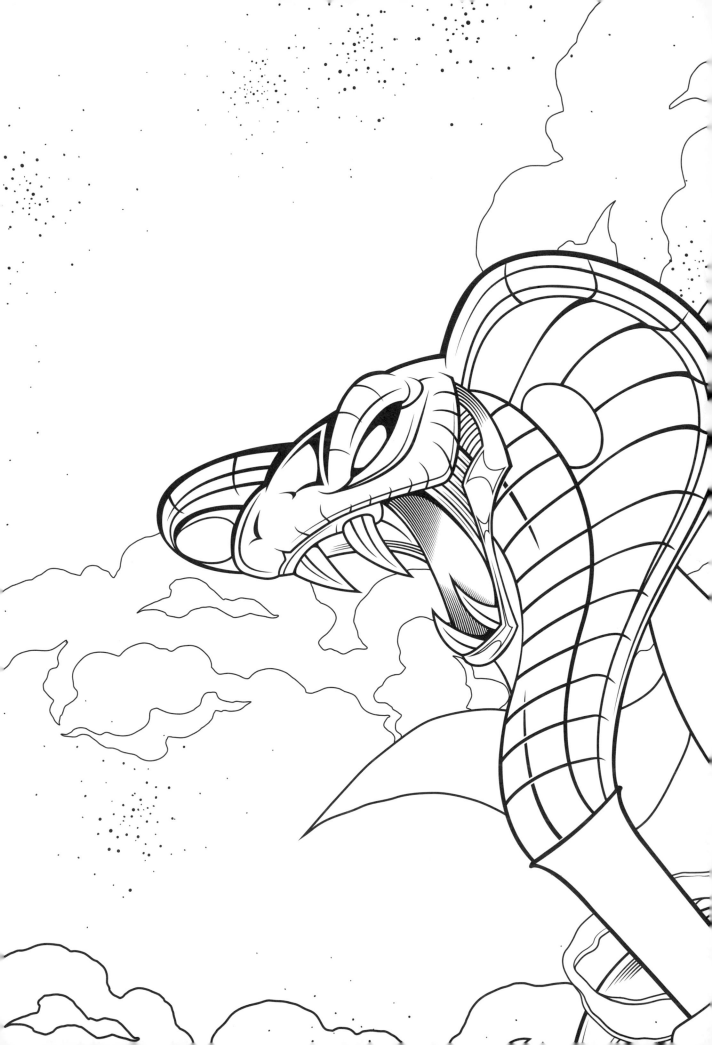

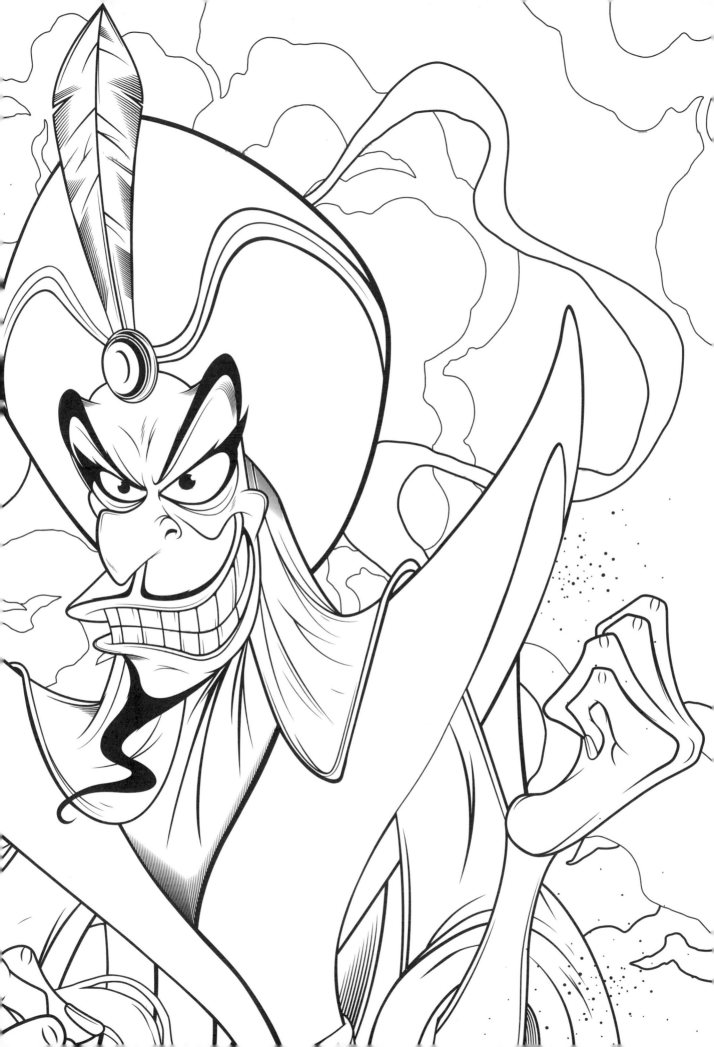

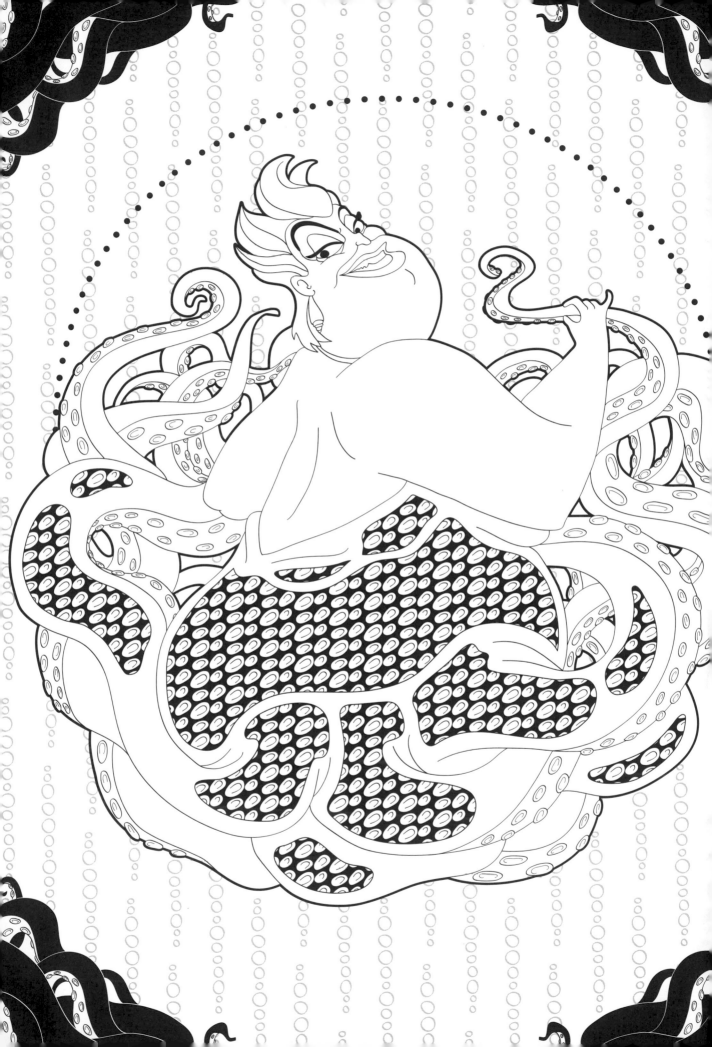

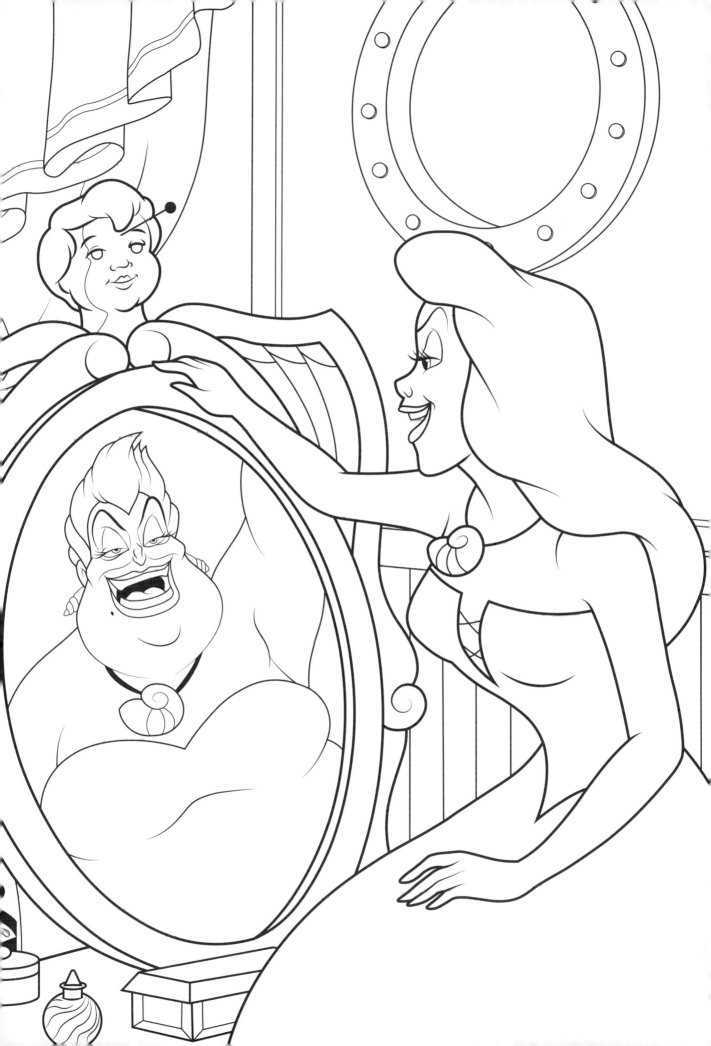

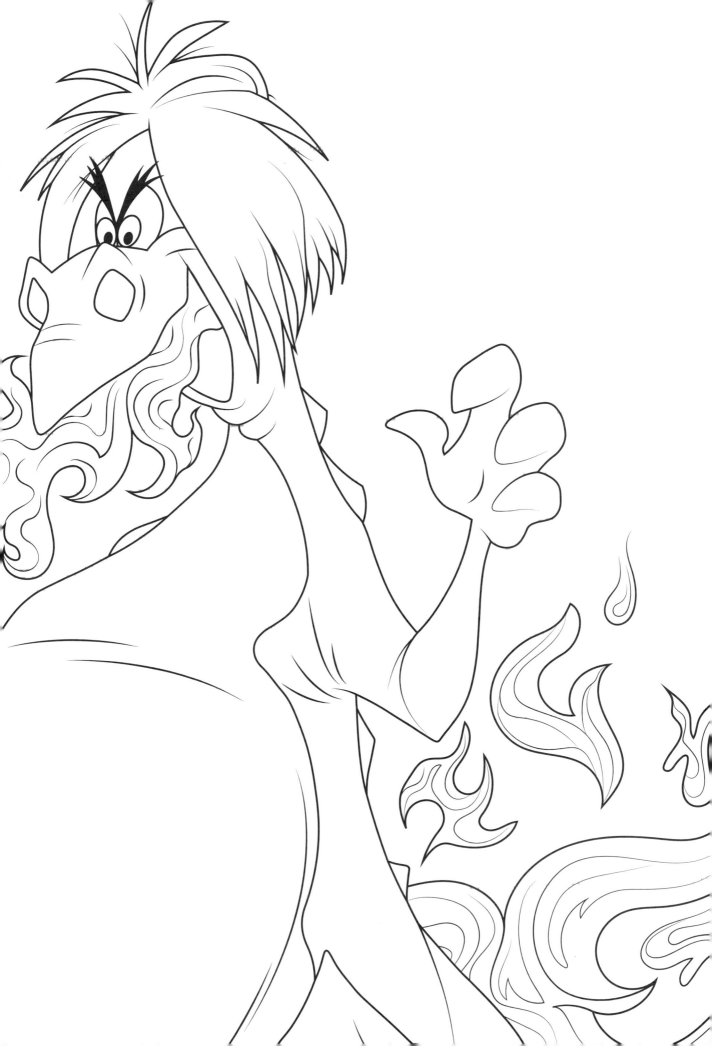

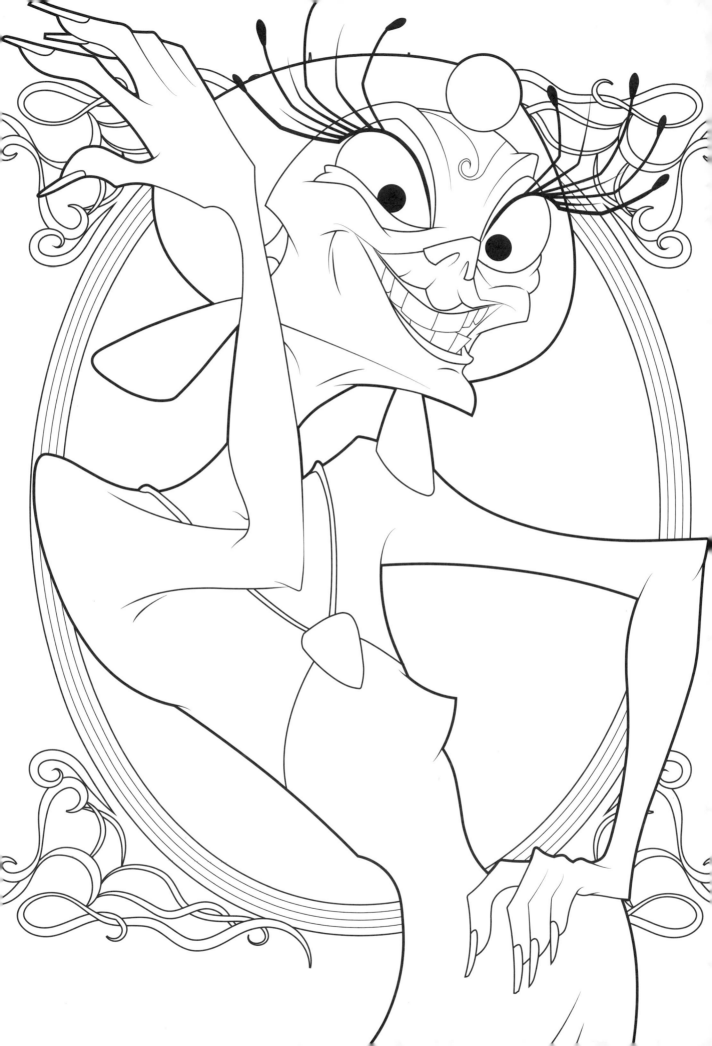

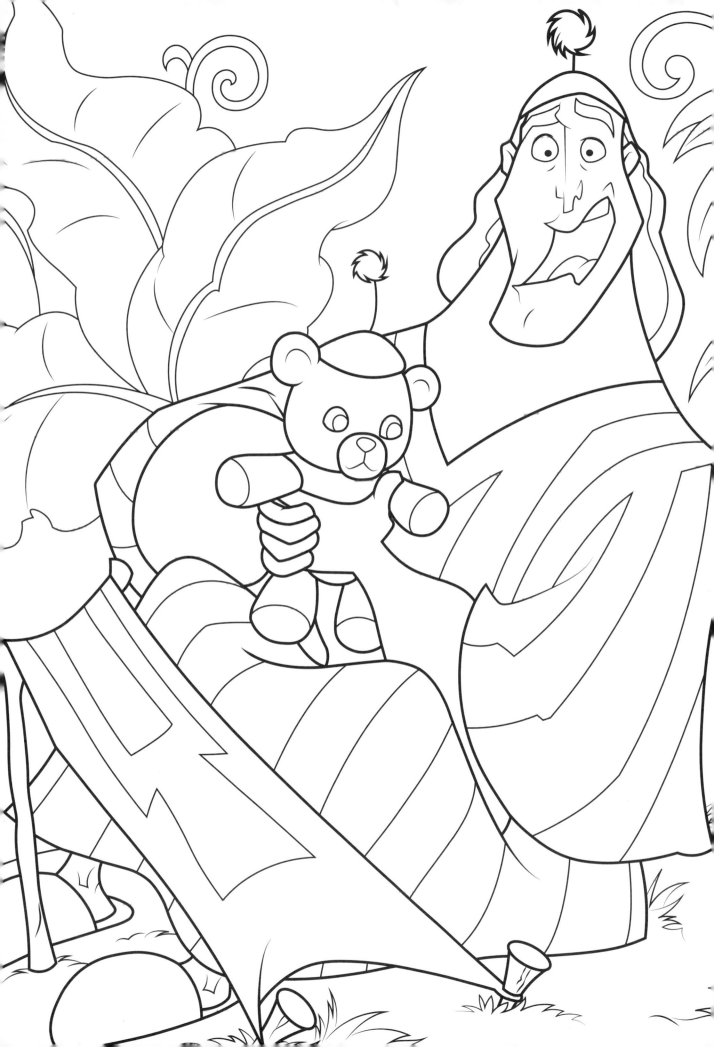

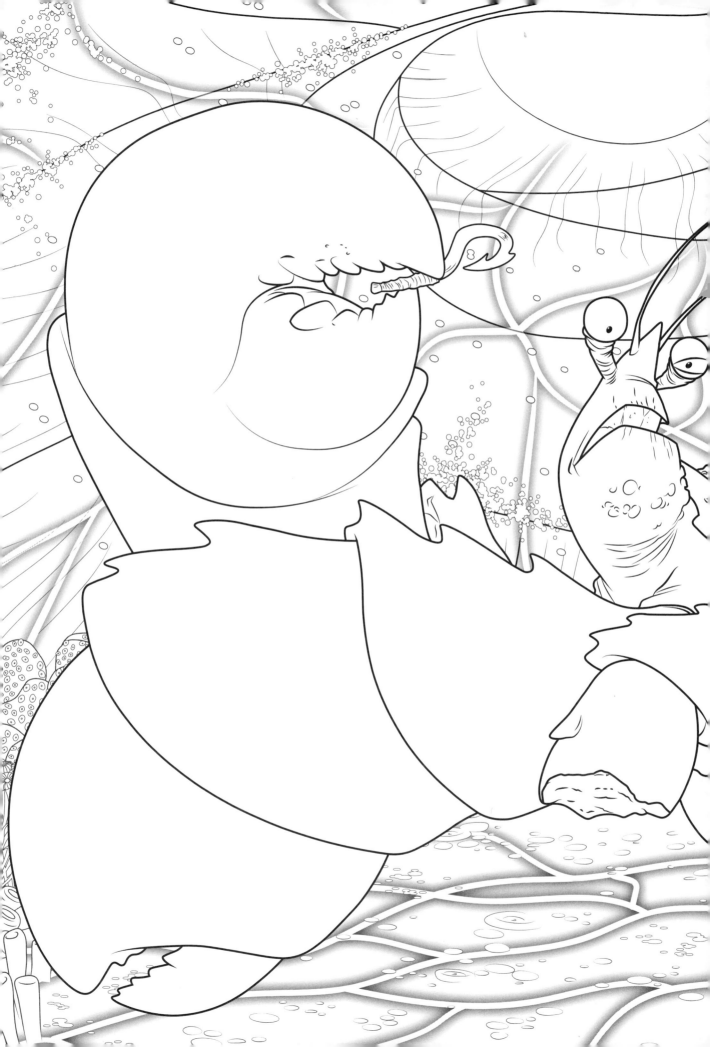

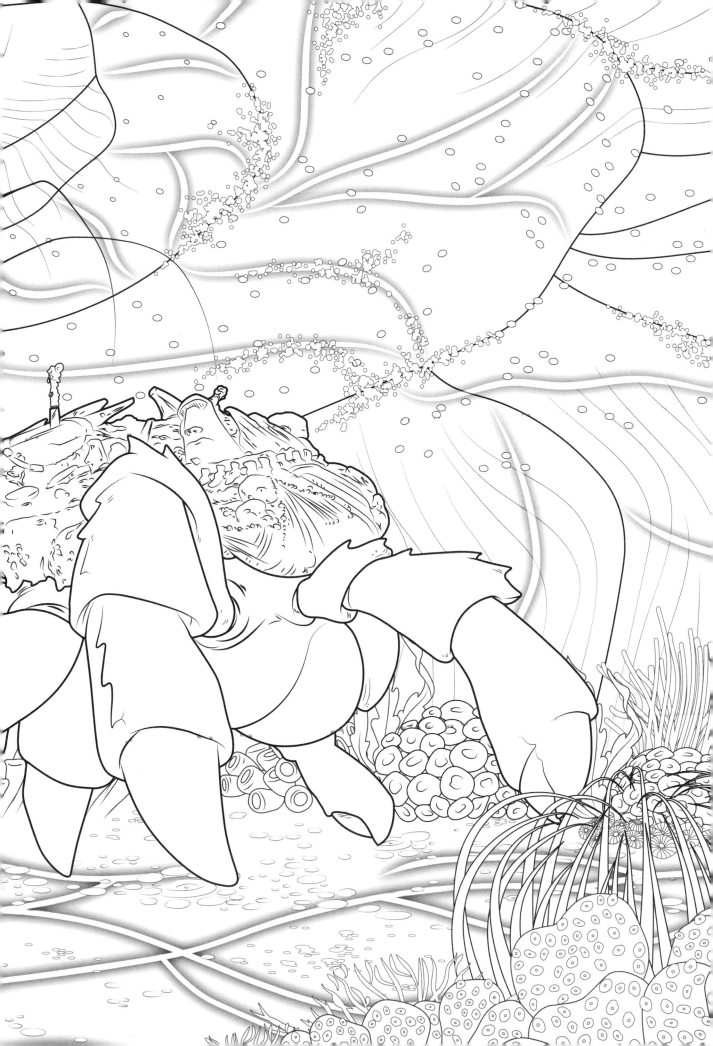

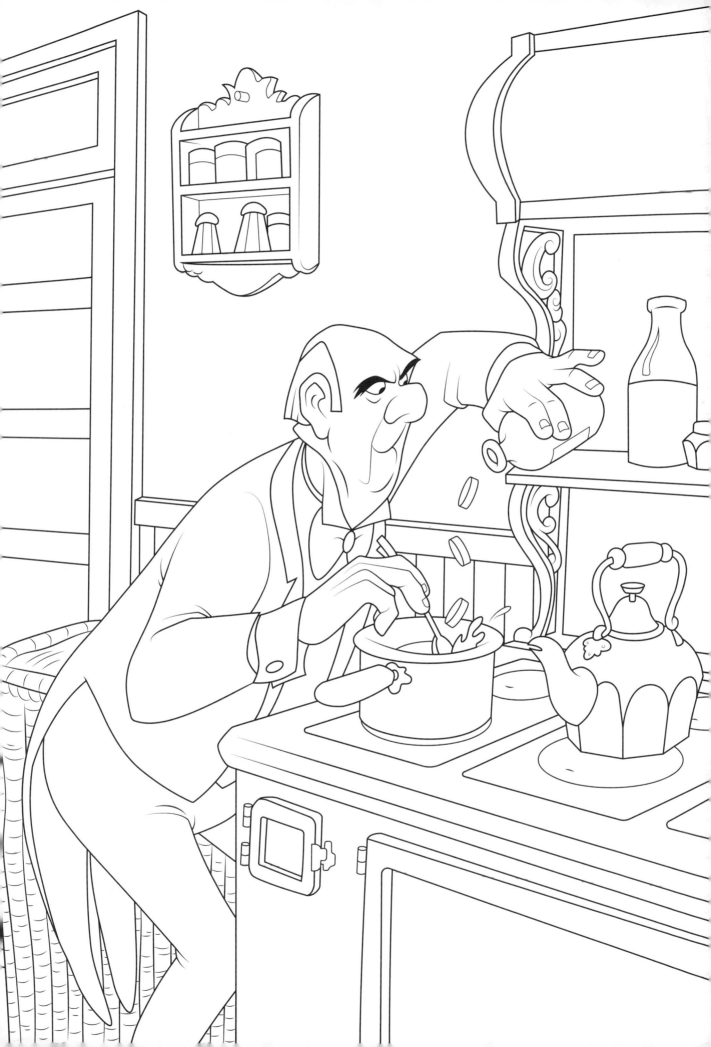

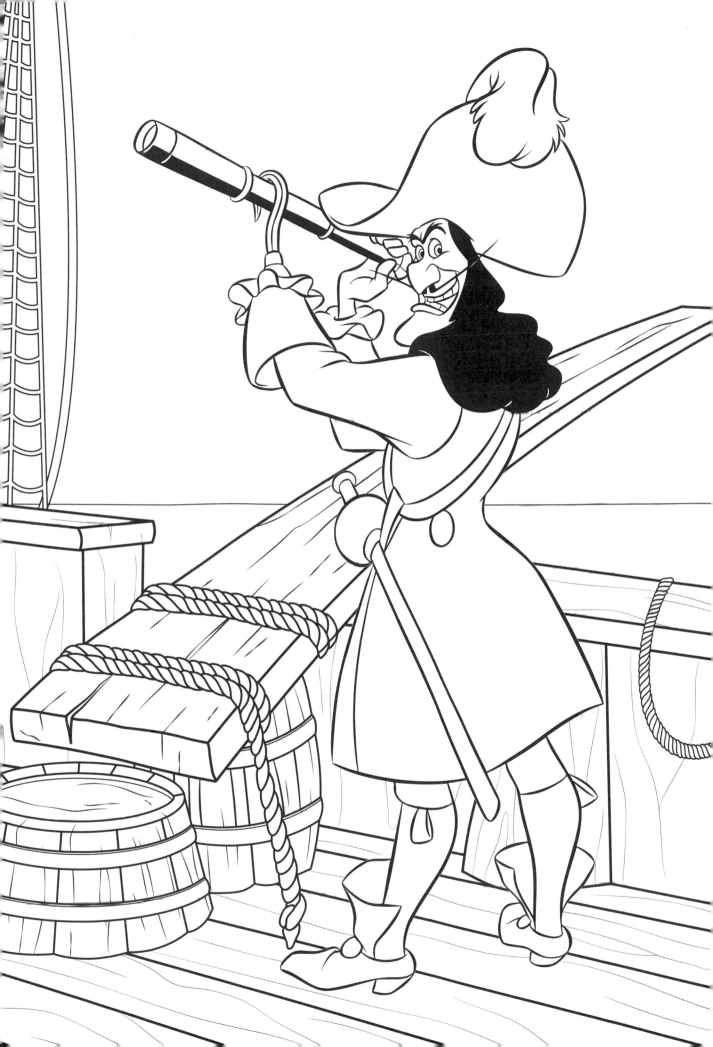

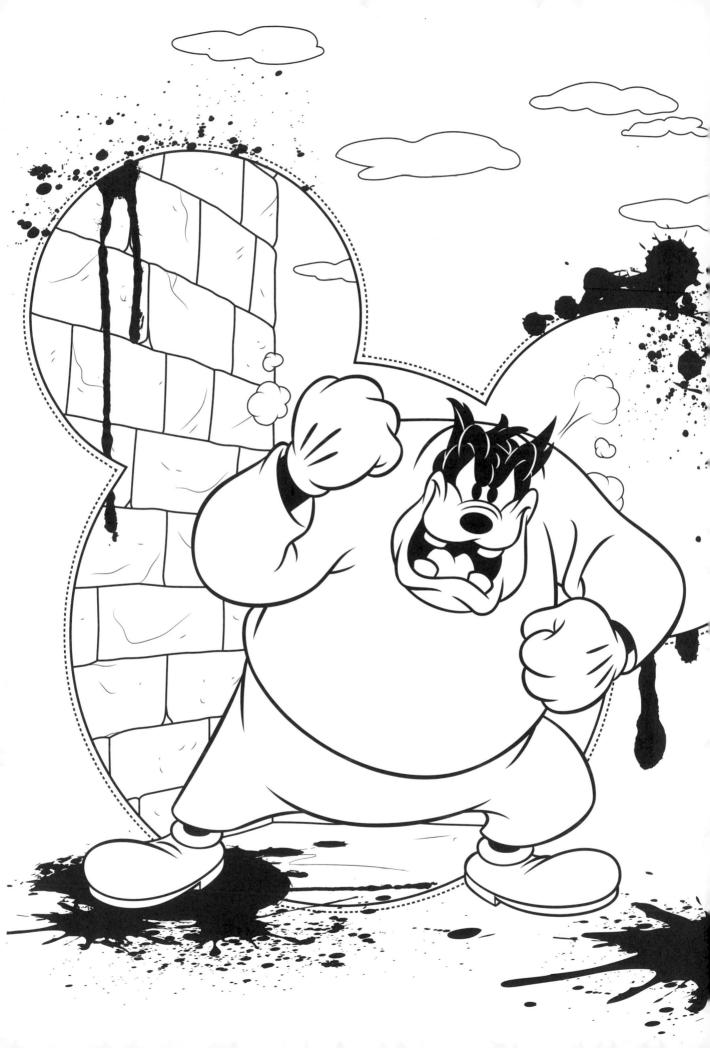

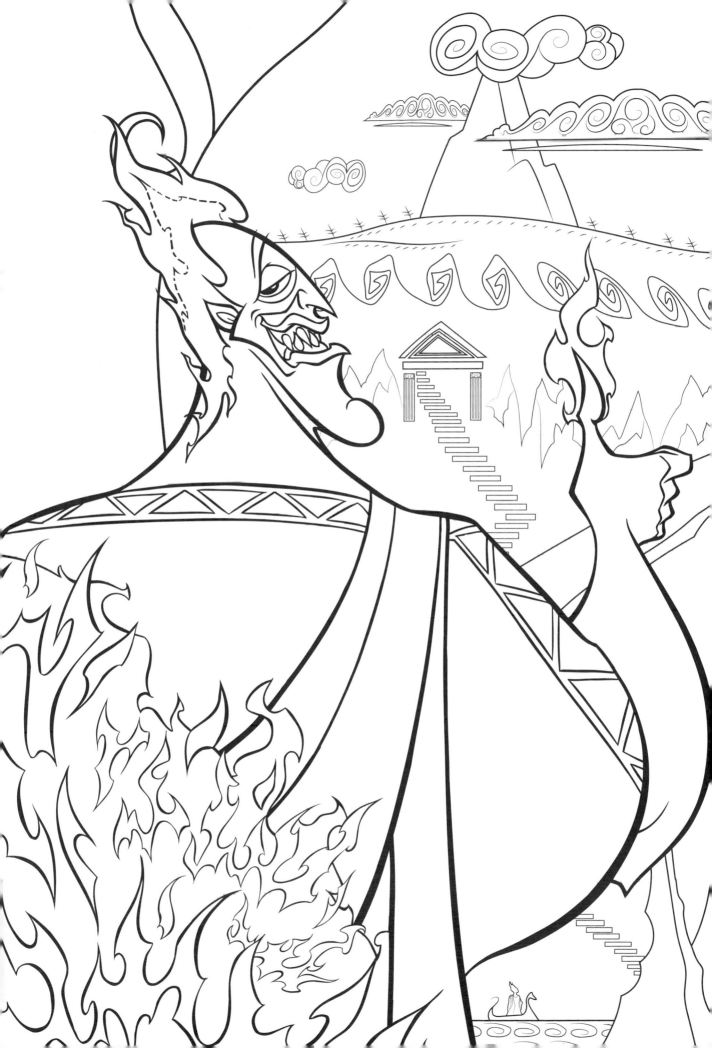

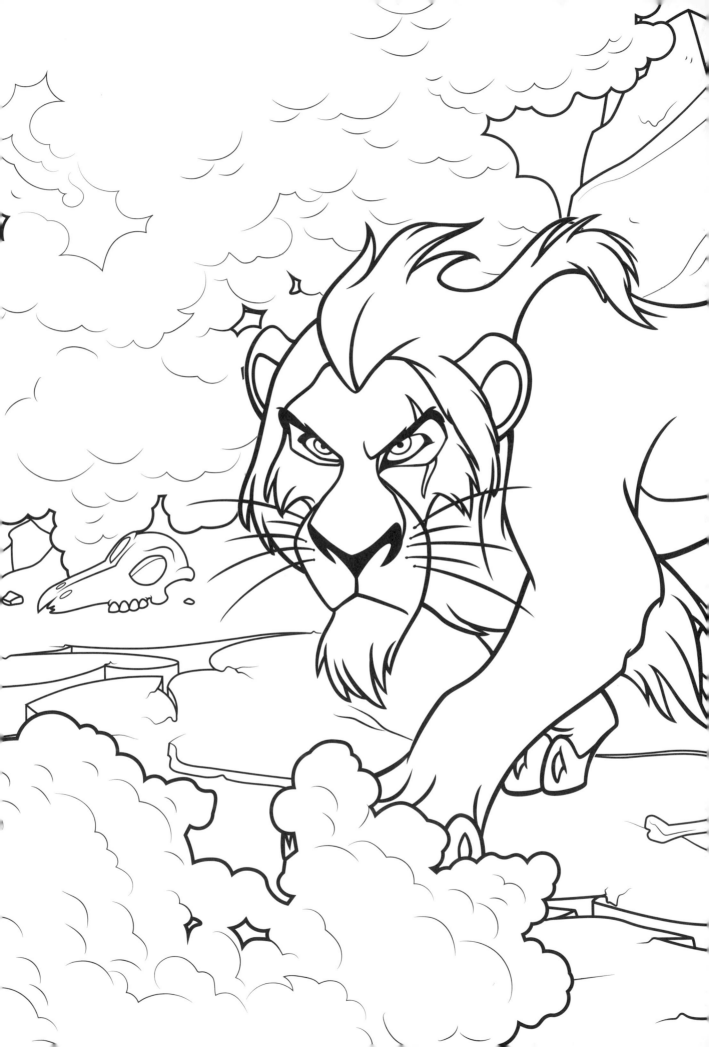

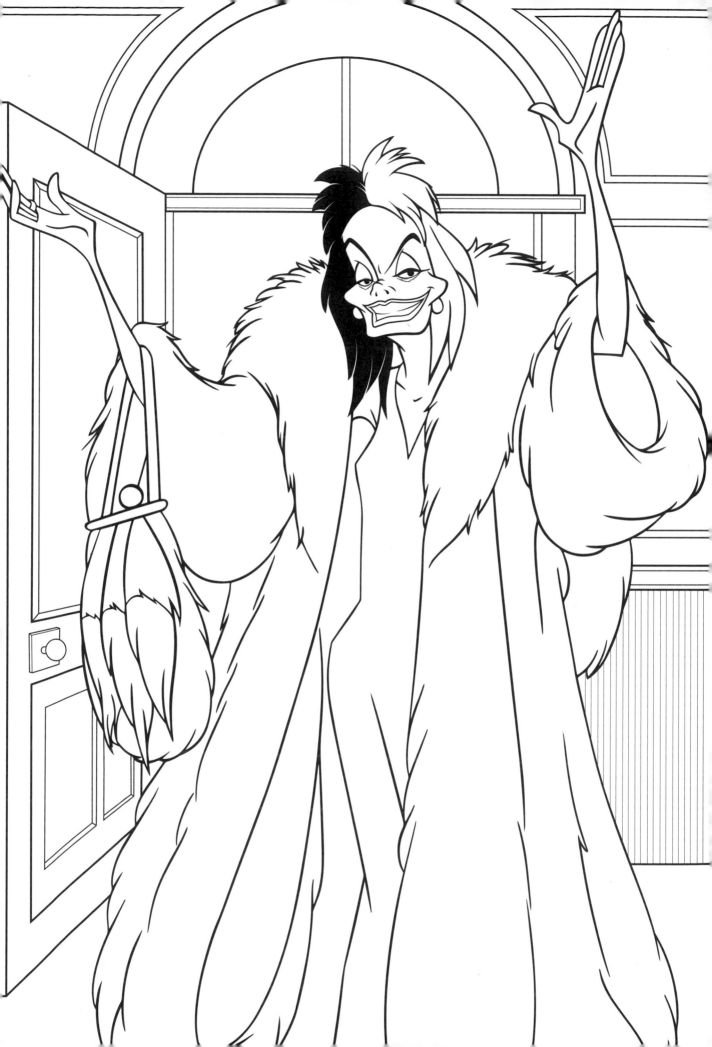

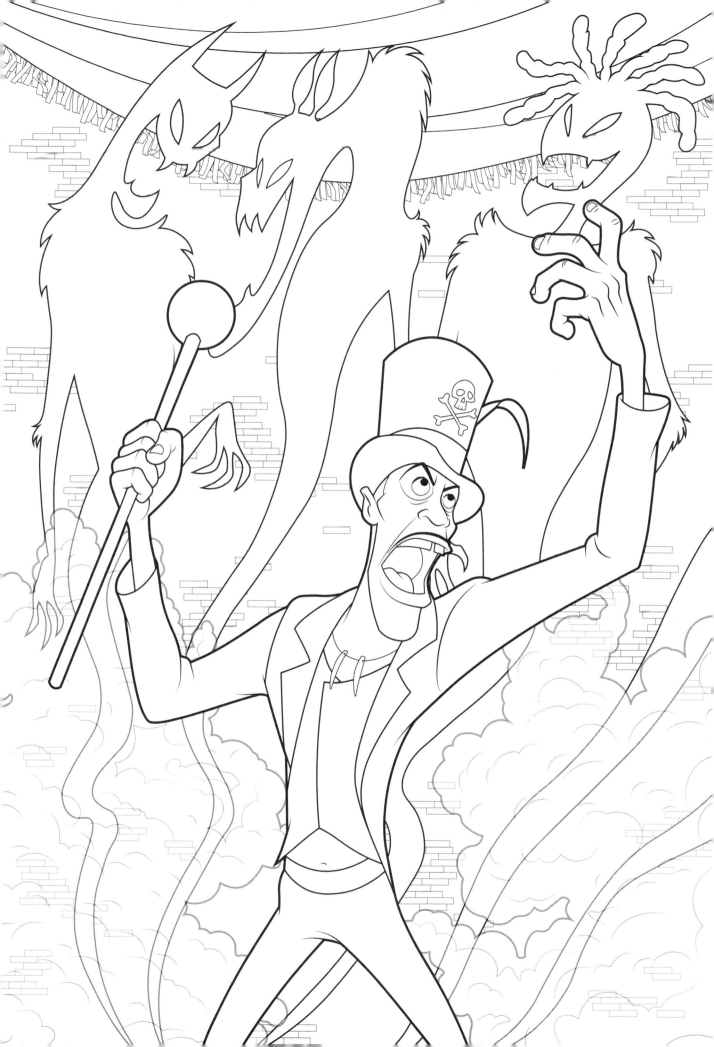

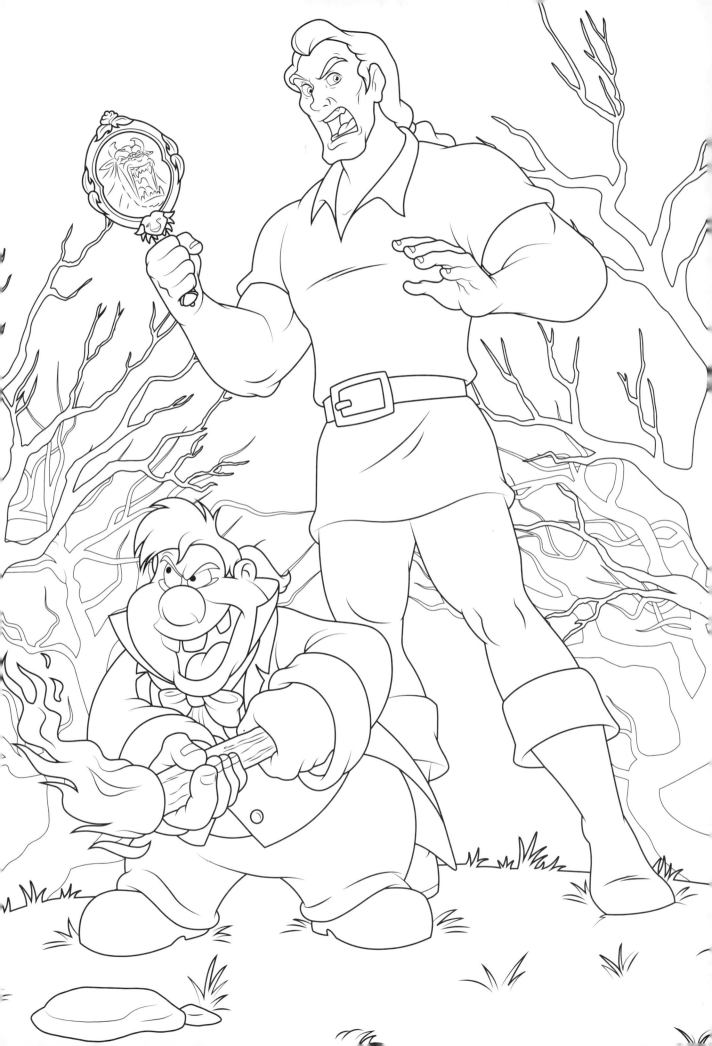

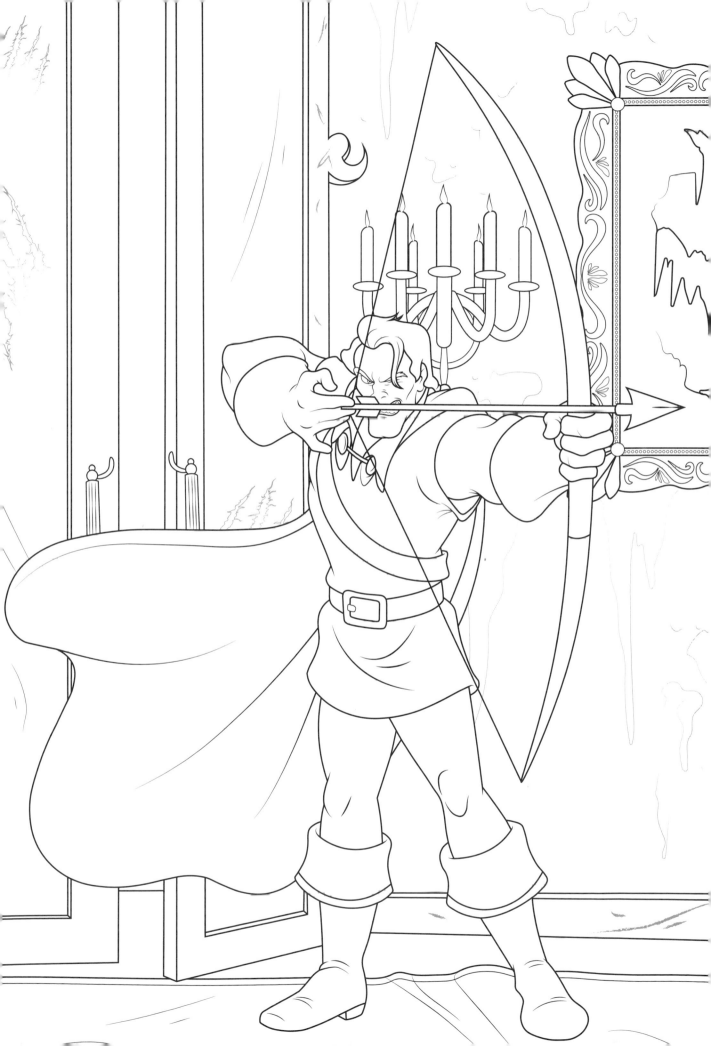

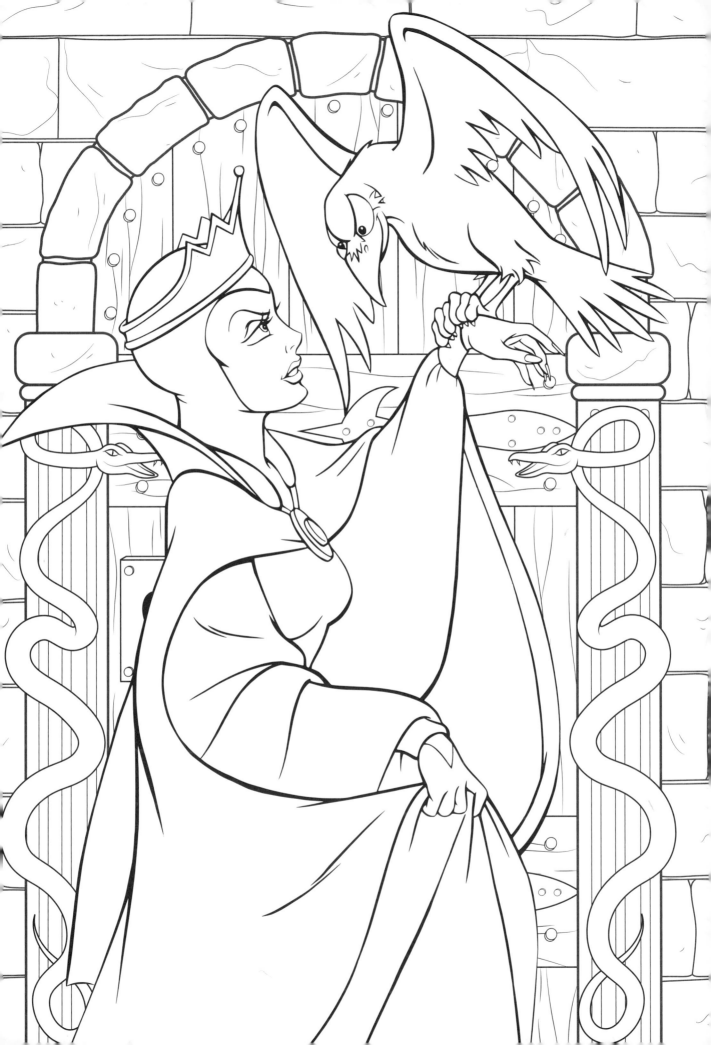

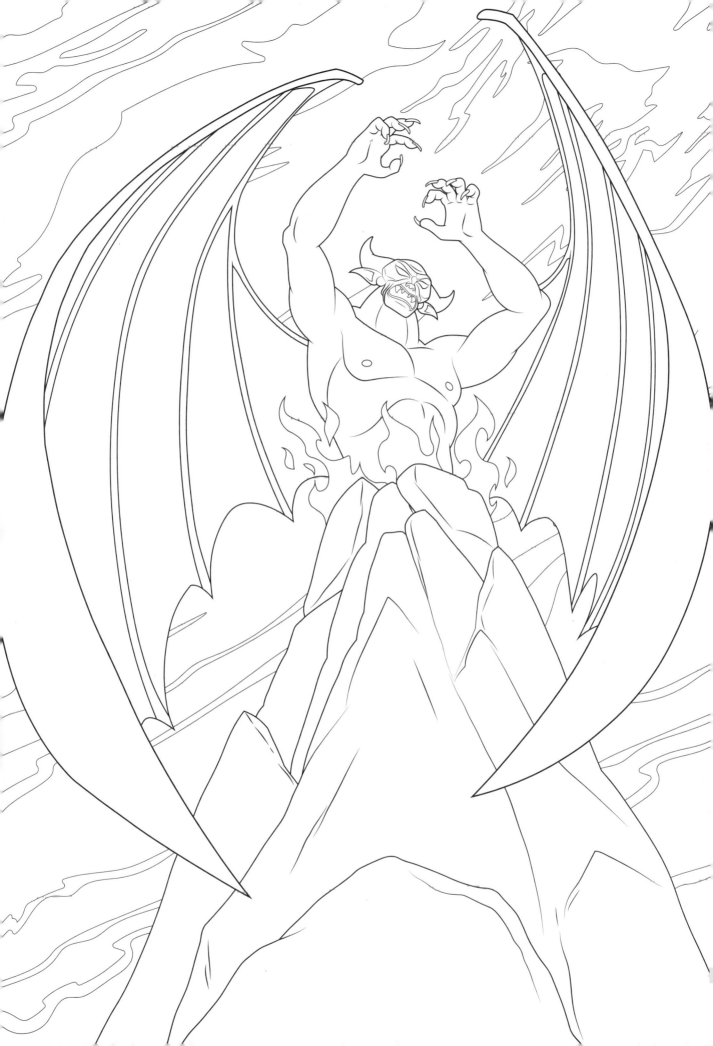

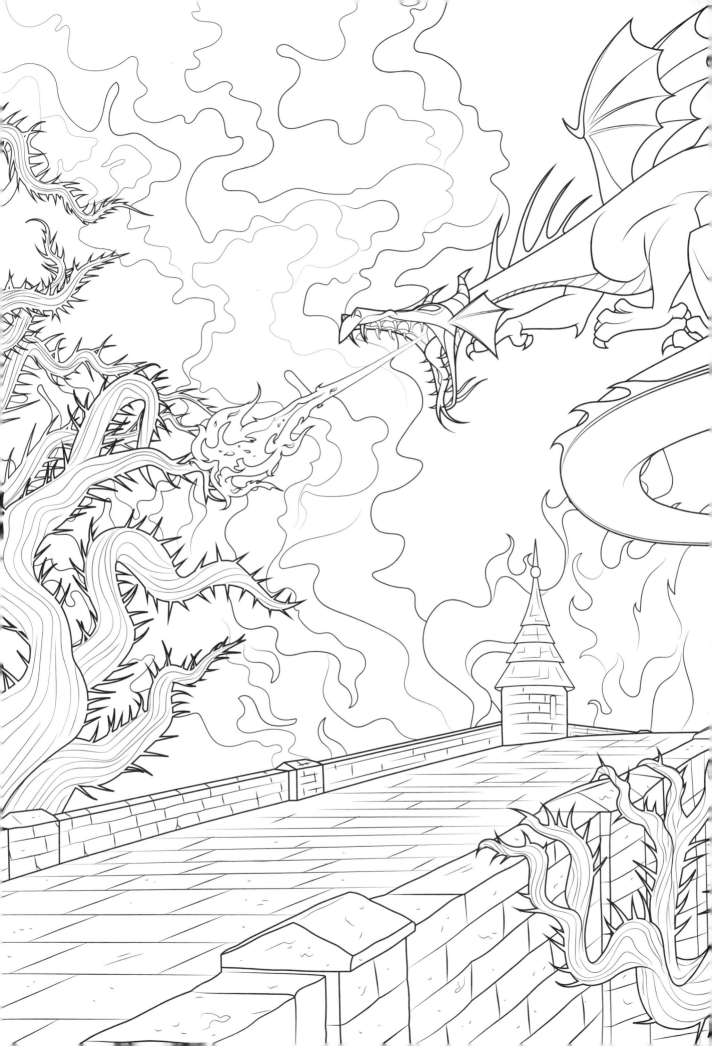

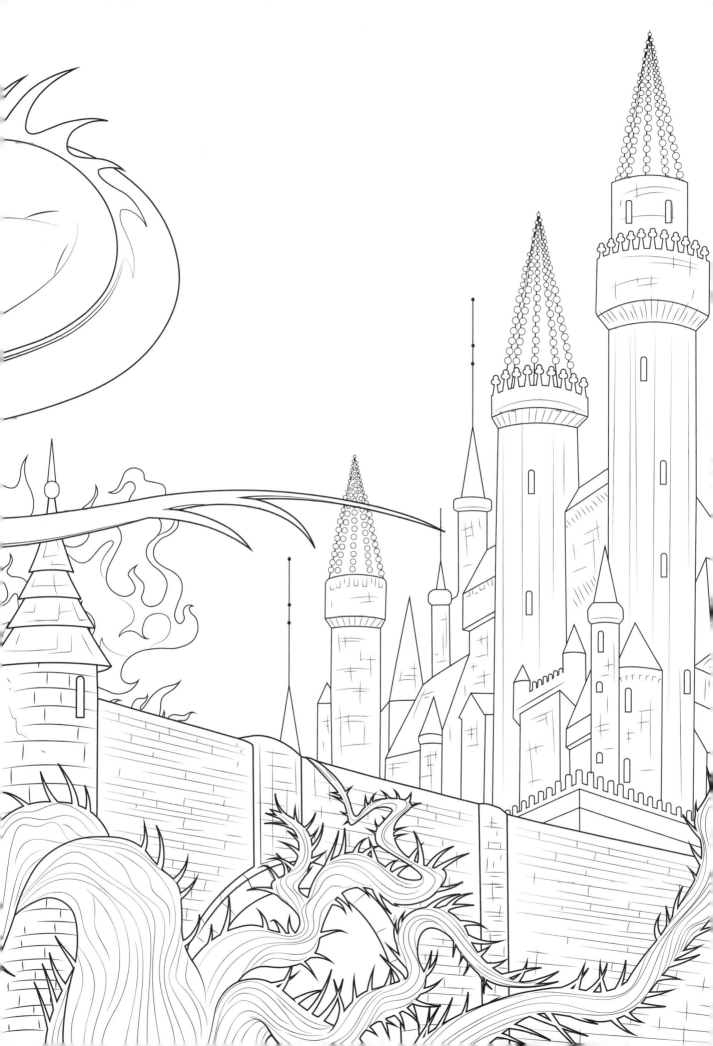

ART OF COLORING
100 IMAGES TO INSPIRE CREATIVITY

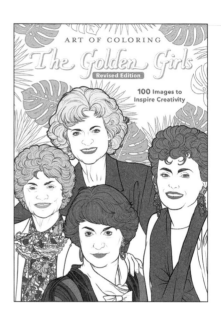

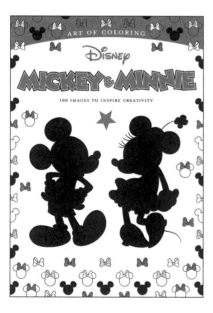

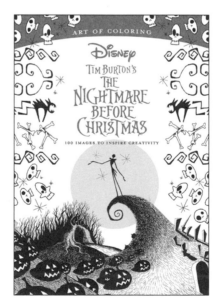

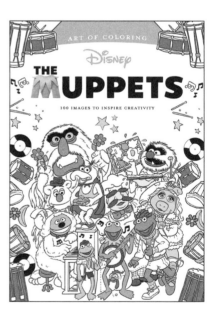

RELAX! COLOR! AND REPEAT!

AVAILABLE NOW